IMAGES OF BASEBALL

THE BOSTON RED SOX
FROM CY TO THE KID

THE BOSTON RED SOX
FROM CY TO THE KID

Mark Rucker and Bernard M. Corbett

ARCADIA
PUBLISHING

Published by Arcadia Publishing
Charleston SC, Chicago IL, Portsmouth NH, San Francisco CA

Printed in the United States of America

Library of Congress Catalog Card Number: 2002113433

For all general information contact Arcadia Publishing at:
Telephone 843-853-2070
Fax 843-853-0044
E-mail sales@arcadiapublishing.com
For customer service and orders:
Toll-Free 1-888-313-2665

Visit us on the Internet at www.arcadiapublishing.com

All photographs credited to Transcendental Graphics

On the cover: Huntington Avenue, home of the Boston American League team from 1903 to 1911, was the site of the first-ever World Series game on October 1, 1903. Pittsburgh defeated Boston 7-3 in game one. The Red Sox won the inaugural World Series five games to three. The eighth and deciding game was played at the Huntington Avenue Grounds.

CONTENTS

INTRODUCTION

On January 28, 1901, the city of Boston, a longtime National League stronghold, was granted a franchise in the rival American League. Along with Chicago and Philadelphia, Boston was one of three two-team baseball cities vital to the league's success or failure.

Although commonly referred to in the press by nicknames such as the Pilgrims, Puritans, Plymouth Rocks, and Somersets, the Boston American League ball club was known as the Americans until 1907. Owner John I. Taylor, son of *Boston Globe* publisher General Chubb Taylor, renamed the team that year. The nickname "Red Sox" was then introduced and has remained to the present day.

The Americans' first season of competition produced a record of 79-57 and a second-place finish. More importantly, the team drew more than 300,000 fans to its new ballpark, the Huntington Avenue Grounds. The strong showing at the gate established the fledgling league in Boston.

In 1903, the Americans hosted the first World Series game and eventually won the first best-of-nine series, five games to three, defeating the Pittsburgh Pirates. Under the on-field guidance of player-manager Jimmy Collins, the Americans were the first world champions of baseball.

The Royal Rooters, Boston's rabid group of fans, led by local saloon owner "'Nuf Ced" McGreevy, had reason to celebrate. Arriving in Boston at age 33 in 1901, pitching legend Cy Young won 192 of his 511 career victories in a Boston uniform over the next eight seasons, including a win in the pivotal tie-breaking seventh game of the series.

The glory of the 1903 series triumph was quickly swept away. Another first-place finish in 1904 did not give the Americans a chance to repeat as world champions. The National League champion New York Giants refused to play a World Series.

Eight long years passed before the now Red Sox entered their golden age. From 1912 to 1918, Boston captured pennants and world titles four times. Pitcher Smoky Joe Wood, player-manager Bill Carrigan, third baseman Larry Gardner, and the incomparable outfield trio of left fielder Duffy Lewis, center fielder Tris Speaker, and right fielder Harry Hooper were among the key elements that shaped the team's era of dominance. The addition of a young left-handed pitching phenomenon named George Herman Ruth during the 1914 season also proved to be a significant event.

Following the 1918 world championship and the departure of Ruth—a budding offensive force (he had hit a record-breaking 29 home runs in 1919) prior to the 1920 season—the Red Sox soon entered a period of deep malaise, finishing dead last for 9 of the 11 years between 1922 and 1932.

The purchase of the team by a 30-year-old millionaire named Thomas Austin Yawkey during the winter of 1932–1933 signaled the dawning of a new era in Boston baseball.

First came the rebuilding of the "new" Fenway Park prior to the 1934 season. Yawkey's subsequent acquisition of player-manager Joe Cronin in 1935 from Washington eventually

paved the way to the addition of players such as Bobby Doerr, Johnny Pesky, Dom DiMaggio, and a gangly kid from San Diego named Ted Williams.

The core of talent that carried the franchise to a postwar resurgence had been put in place by 1942. The return of the "Greatest Generation" produced some of Boston baseball's all-time memorable moments with the greatest hitter of all time at the forefront.

One

THE NEW LEAGUE

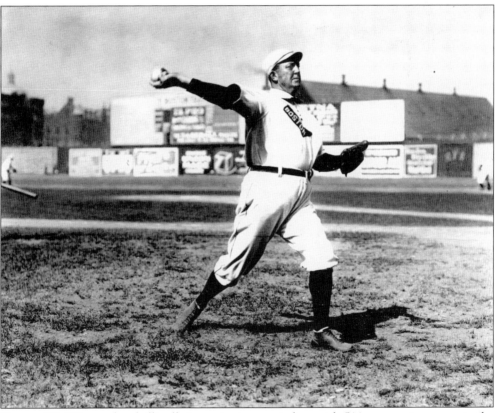

Denton "Cy" Young, baseball's all-time winningest pitcher, with 511 career wins, came to the Boston American League team at age 34 in 1901, the fledgling season of the "Junior Circuit." Young anchored the Red Sox pitching staff for nine seasons, which were highlighted by back-to-back 30-plus winning seasons in 1901 (33-10) and 1902 (32-10). Overall, he won 192 games as a Red Sox hurler, a club record later matched by Roger Clemens. His 2,276 innings pitched, 275 complete games, 38 shutouts, and earned run average (ERA) mark of 2.00 all established team records. He was the only pitcher to win more than 200 games in both the American and National Leagues. In 1956, after Young's death in November 1955, baseball honored him by establishing an annual award for pitching excellence in his name.

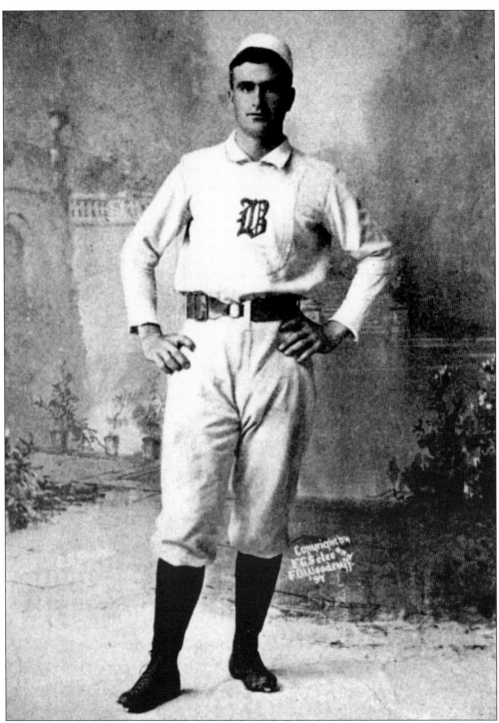

Chick Stahl moved over from the Boston National League entry to join the American League club in 1901. Stahl took charge of the team's outfield as the starter in center from 1901 to 1906. In 1904, he set the club record for triples, with 22. He was the team's player-manager at the time of his death on March 26, 1907, as a result of drinking poison in an apparent suicide.

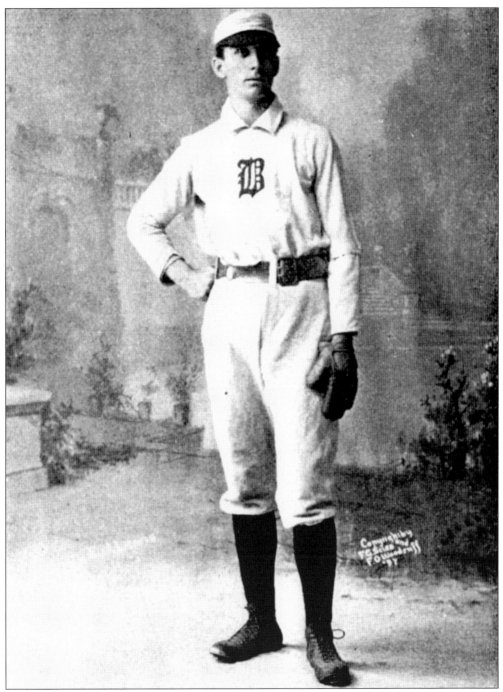

Edward "Parson" Lewis was another player who made the transition from the Boston National League team to become a member of the inaugural Boston American League team. He spent just one season (1901) with the club, compiling a record of 16-17, with a 3.53 ERA. It would be Lewis's final season in major-league baseball. A well-educated man with two degrees from Williams College, Lewis was a close friend of Robert Frost and served as a president of the University of New Hampshire.

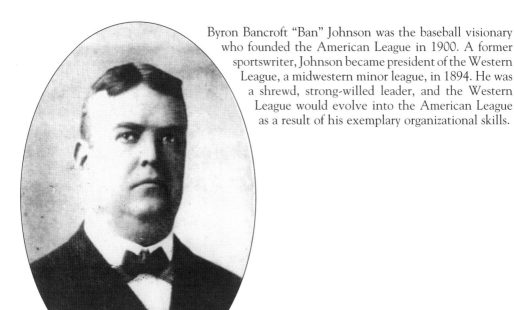

Byron Bancroft "Ban" Johnson was the baseball visionary who founded the American League in 1900. A former sportswriter, Johnson became president of the Western League, a midwestern minor league, in 1894. He was a shrewd, strong-willed leader, and the Western League would evolve into the American League as a result of his exemplary organizational skills.

Buck Freeman was also a member of the Boston National League team prior to joining the American League club in 1901. The first baseman and outfielder has the distinction of leading the first Boston American League team in all three major offensive categories in their first season, with 12 home runs, 114 runs batted in, and a .339 batting average. Freeman played in Boston for seven seasons, finishing his career in 1907. His 25 home runs in 1899 for the Washington National League team remained a single-season record until Babe Ruth slugged 29 round-trippers in 1919.

Lou Criger was a key signing for Boston's American League team prior to the 1901 season. He followed Cy Young from St. Louis to catch the 34-year ace at his new address. A solid defensive catcher, Criger spent the next eight seasons with Boston, battling through assorted injuries to remain the team's number one receiver.

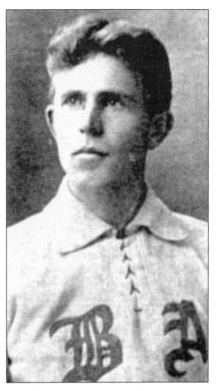

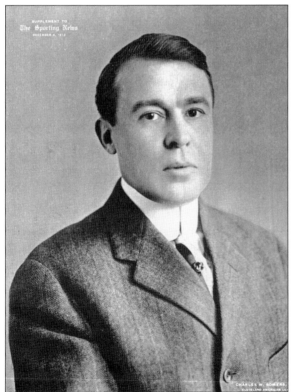

Charles Somers became the first owner of the Boston American League entry in 1901. The team, alternately known as the Pilgrims, Americans, and Somersets, was financed by Somers as a result of a deal with American League president Ban Johnson. A native of Cleveland, Ohio, Somers had a lucrative business in coal, lumber, and shipping.

13

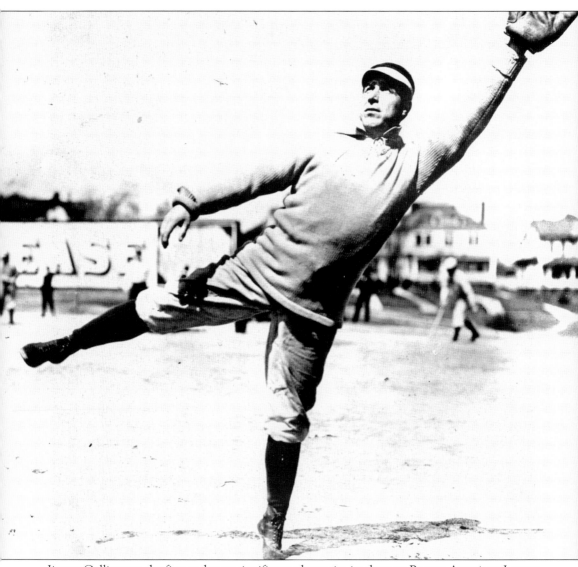

Jimmy Collins was the first and most significant player signing by new Boston American League owner Charles Somers. A standout third baseman for the Boston National League entry from 1896 to 1900, Collins became the Red Sox player-manager for the next five seasons before leaving the team during the 1906 campaign.

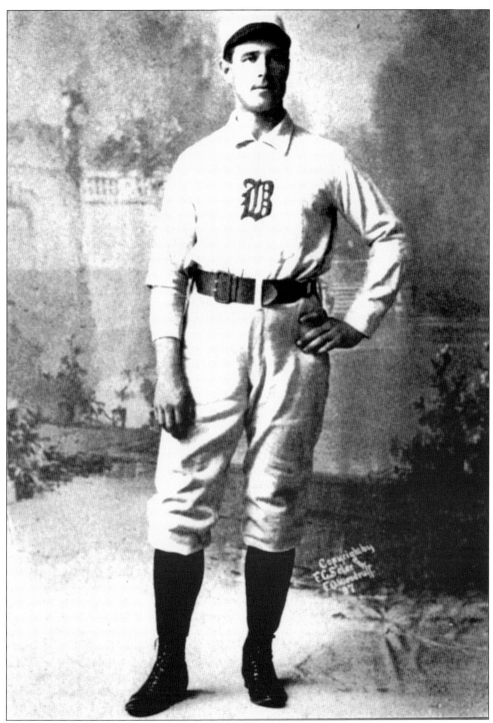

As an Irish-Catholic in Boston, Jimmy Collins was a fan favorite as a National Leaguer, leading the club to championships in 1897 and 1898. He revolutionized defensive play at the third-base position and still holds the National League record for total chances in one season, with 601 in 1899.

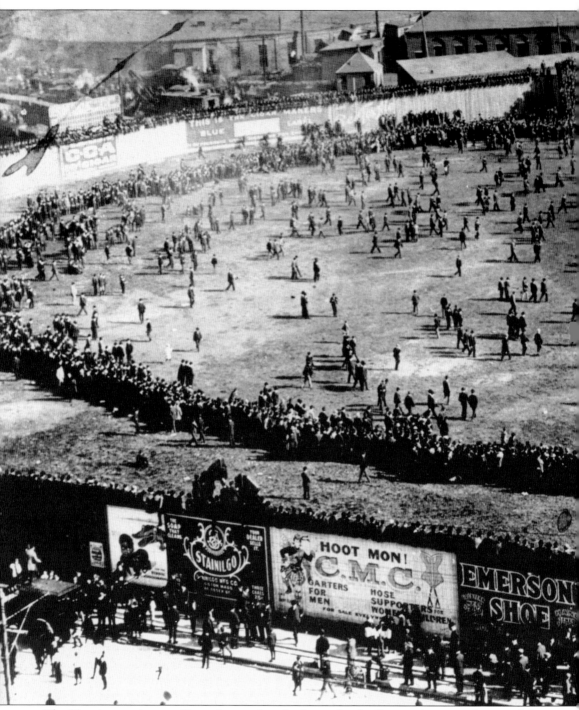

The Huntington Avenue Grounds served as the home for the Boston American League club from 1901 to 1911. The ballpark was built at an estimated cost of $35,000. A wood-frame facility with a concrete facing on the main, roofed grandstand, the new home for Boston baseball would also have bleachers down the right- and left-field foul lines. Amazingly constructed over a two-month period, the park opened on May 8, 1901, with Boston's 12-4 victory over

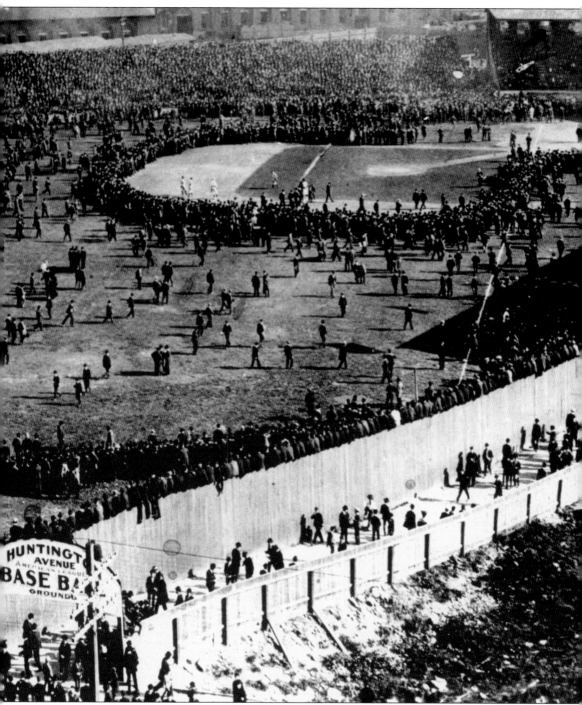

Philadelphia. Separated from the National League park (South End Grounds) by the tracks of the New Haven Railroad, the site is currently occupied by Northeastern University's Cabot Gymnasium. A statue of Cy Young was placed at the point of the original location of home plate in 1993.

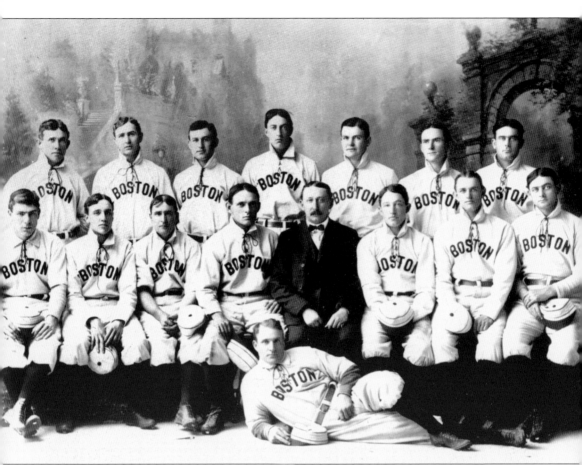

The Boston Americans claimed the distinction of first World Series champions in 1903. Under the direction of player-manager Jimmy Collins, Boston compiled a record of 91-47 to win their first American League pennant. Right fielder Buck Freeman led the league in both home runs (13) and runs batted in (104), and Cy Young's 28 wins and 342 innings pitched paced all American League hurlers. The Pittsburgh Pirates, the National League champions with a record of (91-49), provided the opposition in the first World Series. Game one was played at Boston's Huntington Avenue Grounds. The Pirates' Deacon Phillippe went the distance on the mound to defeat Cy Young 7-3. The Americans recovered, as Young notched wins in games five and seven. The legendary moundsman would be outperformed in the inaugural series by teammate Bill Dineen, who racked up three wins, including a 3-0 shutout in game eight. The Americans captured the series five games to three.

Pictured is a 1903 World Series program cover. Note that the phrase "World Series" had not become part of the common parlance, thus the reference to the World's Championship Games. The advertisement for "McGreevy on the Avenue 'Nuff Said" is for McGreevy's Third Base Saloon, acknowledged as the nation's first sports bar, located on Columbus Avenue between Boston's two major-league ballparks in the early 1900s.

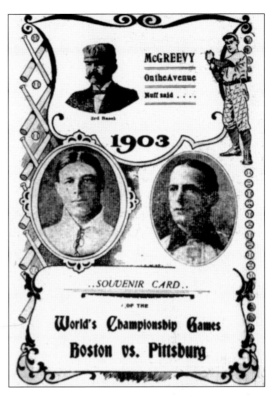

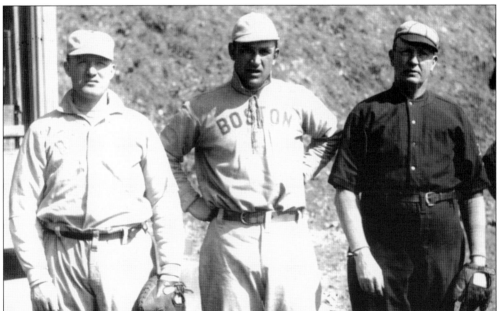

At spring training *c.* 1909–1910 in Hot Springs, Arkansas, from left to right, are catcher Bill Carrigan (1906, 1908–1916), first baseman Jake Stahl (1903, 1908–1910, 1912–1913), and pitcher Cy Young. They would return to the venue for two other stints (1912–1918) and (1920–1923). It was the second spring-training site in the state of Arkansas, preceded by Little Rock (1907–1908). Carrigan and Stahl both went on to manage the Red Sox.

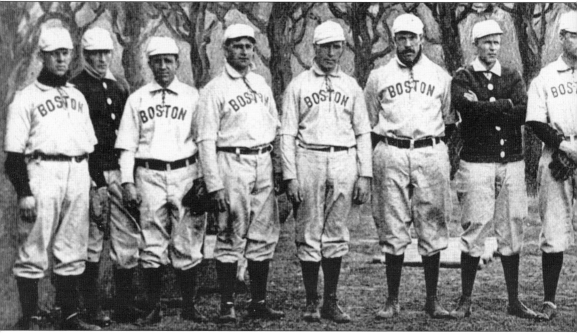

The 1904 Red Sox won their second consecutive American League pennant, with a record of 95-59. The slugging star was again right fielder Buck Freeman, who led the team with 7 home runs and 84 runs batted in. Center fielder Chick Stahl's .295 batting average led all Boston hitters. The pitching staff featured a trio of 20-game winners: Cy Young (27), Bill Dineen (23),

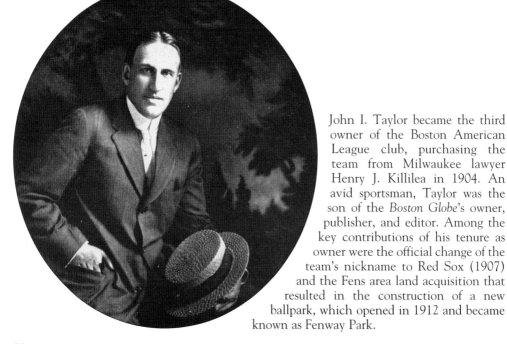

John I. Taylor became the third owner of the Boston American League club, purchasing the team from Milwaukee lawyer Henry J. Killilea in 1904. An avid sportsman, Taylor was the son of the *Boston Globe*'s owner, publisher, and editor. Among the key contributions of his tenure as owner were the official change of the team's nickname to Red Sox (1907) and the Fens area land acquisition that resulted in the construction of a new ballpark, which opened in 1912 and became known as Fenway Park.

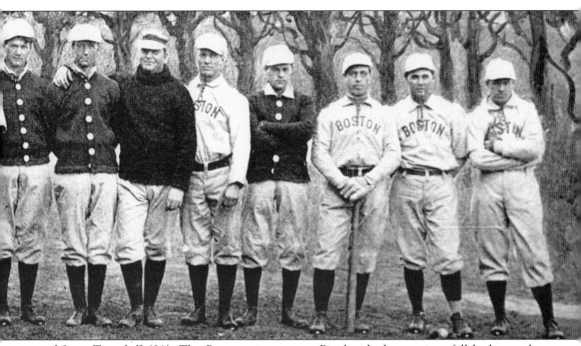

and Jesse Tarnehill (21). The Boston victory over Pittsburgh the previous fall had caused such an embarrassment to the "Senior Circuit" that John McGraw's New York Giants, the 1904 National League champions, refused to play the team. This photograph appeared in *Burr-McIntosh* magazine.

Bill Dineen was not a member of the original Boston American League entry in 1901, much to the chagrin of player-manager Jimmy Collins, but would more than make up for it with his pitching accomplishments after joining the team in 1902. Dineen collected 65 of his 87 overall wins as a Boston pitcher between 1902 and 1904. His 1903 World Series record of 3-1 included complete game victories in games two and eight. During the 1904 season, Dineen amazingly started and finished all 37 games he pitched (23-14). A career highlight was a 1905 no-hitter versus Chicago. Dineen went on to a career as a major-league umpire.

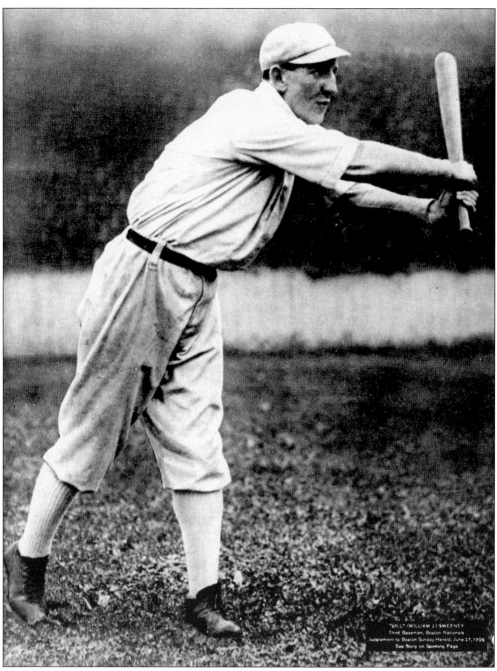

Bill Sweeney spent two of his three major-league seasons with the Red Sox (1930–1931). He spent his first season in Boston as a part-time first baseman before taking over the starting position. He hit a solid .295, with 58 runs batted in, for the 1931 ball club.

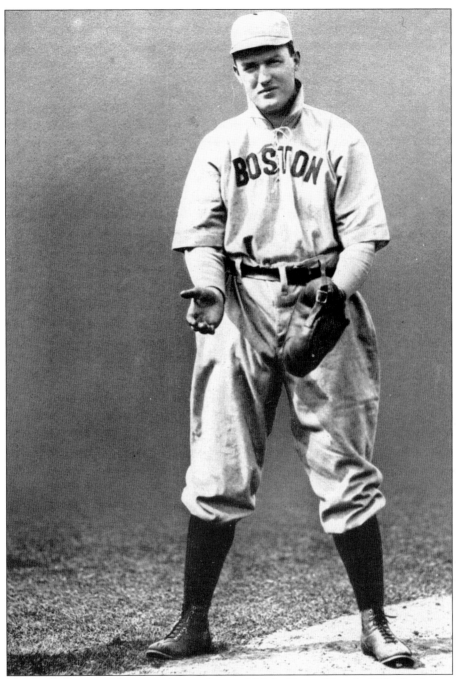

A native of Lewiston, Maine, and a graduate of Holy Cross, "Rough Bill" Carrigan was a true New Englander. A stalwart behind the plate as the team's catcher for a decade, Carrigan also managed the Red Sox for seven years (1913–1916, 1927–1929), guiding the team to consecutive world championships in 1915 and 1916. His players lauded his managerial expertise, particularly his ability to bring out the best in his ball clubs. The origin of Carrigan's nickname hankered back to his toughness defending home run plate against spikes-flying base runners.

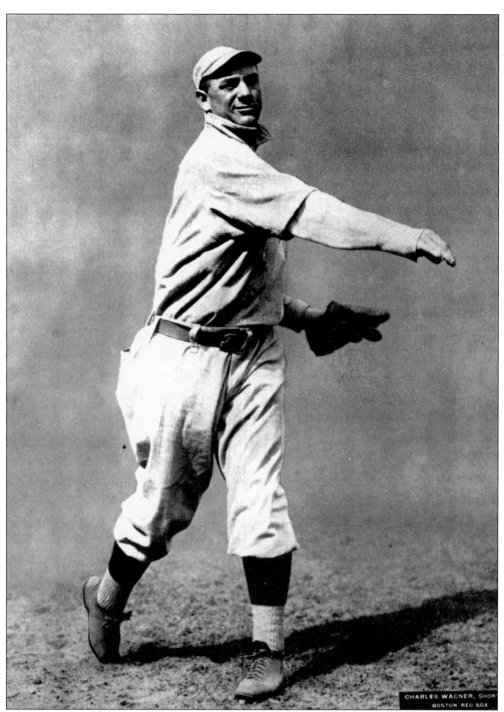

CHARLES WAGNER, SHOR
BOSTON RED SOX

Charlie "Heinie" Wagner spent 11 years with the Red Sox, starting at shortstop for six seasons and second base for two. Only a .250 lifetime hitter, Wagner remained a key offensive contributor as a result of a keen batting eye, which allowed him to increase his on-base percentage significantly via the base on balls. A Red Sox team captain and member of three world championship teams, Wagner managed the team for one season, in 1930.

Pitcher Eddie Cicotte (1908–1912) had his best years in a Red Sox uniform, winning 28 games combined during the 1909 and 1910 seasons. After slumping to 11-14 in 1911, Cicotte was traded to the Chicago White Sox early in the 1912 season. Cicotte's best single season as a professional was in 1919 (29-7), but it was tainted by his involvement with the "Black Sox" gambling scandal.

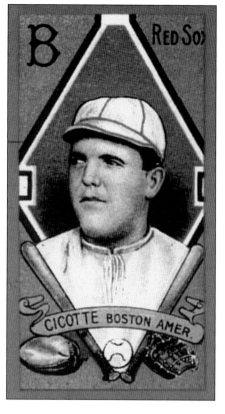

Patsy Flaherty first played in the major leagues during the 1899 season. Flaherty landed in Boston with the National League's Braves in 1907–1908, making 56 starts on the mound and compiling a record of 24-33 overall. After a brief stint with the Pittsburgh Pirates in 1910, he returned to the Braves for the 1911 season. He participated in spring training for the 1912 Red Sox but did not make the club and retired.

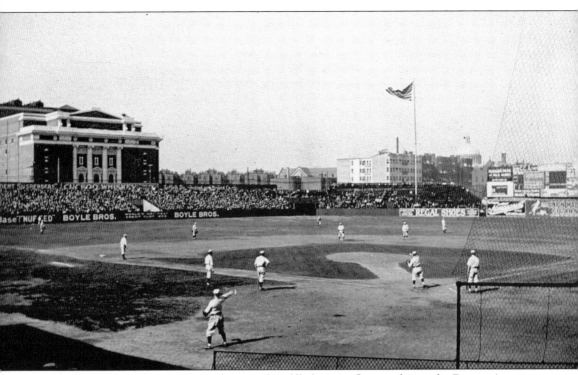

The Huntington Avenue Grounds were often filled to overflowing during the Boston American League's tenure at the ballpark, home to the first ever World Series game (1903). The Americans won a second consecutive pennant in 1904, the year of this photograph. There was no World Series in 1904 and, thus, no world champion.

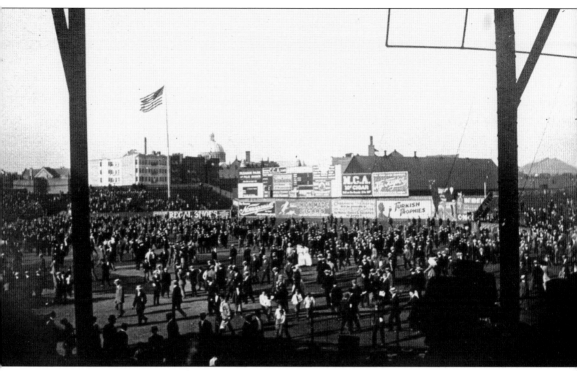

It was not uncommon to see the crowd "take the field" upon a game's completion, as spectators often lined the playing field's outer reaches during play. The advent of concrete and steel parks, coupled with the expiration of the lease at Huntington Avenue in 1911, led to the construction of Fenway Park by John Taylor for the 1912 season.

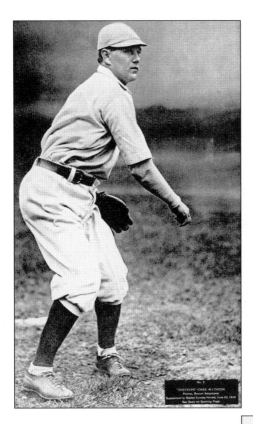

Charlie "Checkers" Chech, a right-handed pitcher, compiled a record of 7-5 in his only Red Sox season.

Harry Niles (1908–1910) broke into the major leagues with the St. Louis Browns in 1906. He split the 1908 season between the Yankees and Red Sox, batting .273 for Boston in 17 games. In the 1909 campaign, Niles's only full year in Boston, he batted .245, with 38 runs batted in, and split his playing time at third base, shortstop, second base, and the outfield. He moved on to Cleveland and finished his career with the Indians in 1910.

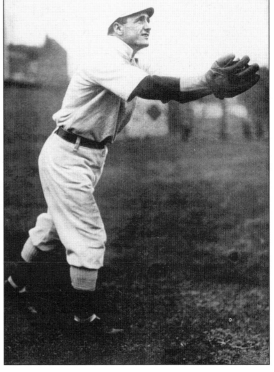

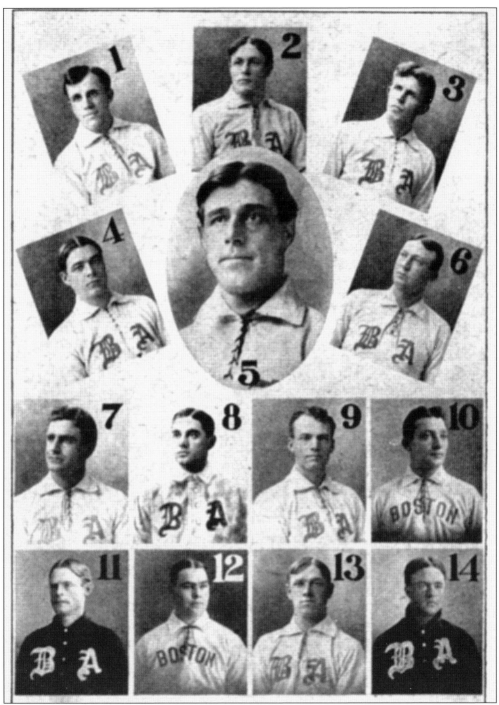

The 1907 Red Sox stumbled to a seventh-place 59-90 finish. The transient manager's position actually found four different men piloting the team, including Hall of Fame pitcher Cy Young, who compiled a 3-4 record during his abbreviated term. At age 41, Young again led the staff in innings pitched (343), wins (19), and ERA (1.99). Right fielder Burk Congalton led the team in hitting, with a .286 batting average in his only season as a member of the Red Sox.

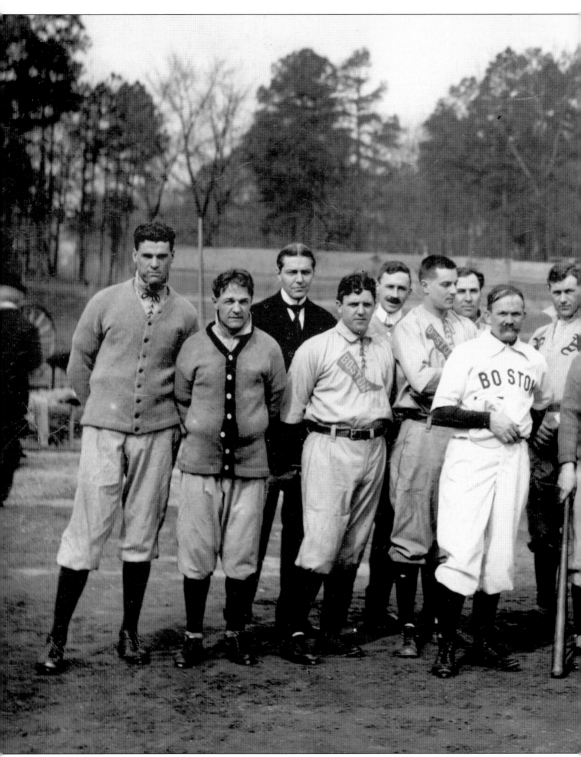

The 1909 club prepares for the season at spring training in Hot Springs, Arkansas. The Red Sox rebounded from their four-year drought (1905–1908) to win 88 games and finish third

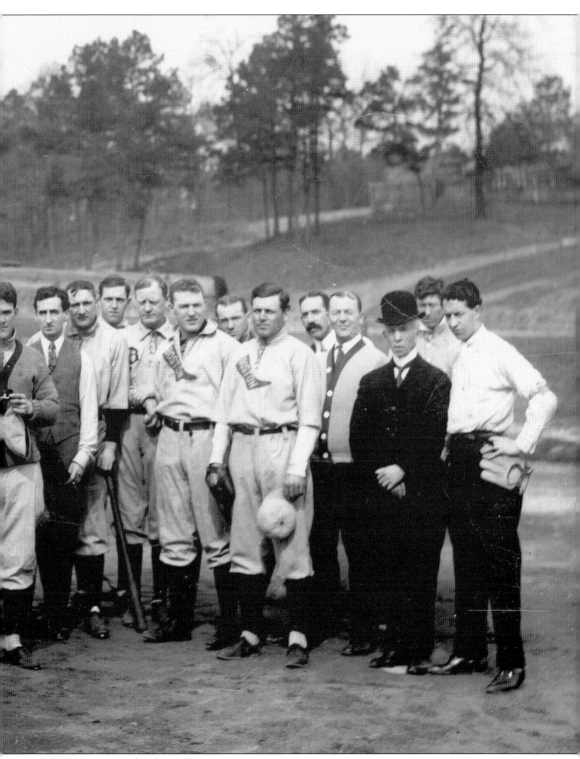

under manager Fred Lake.

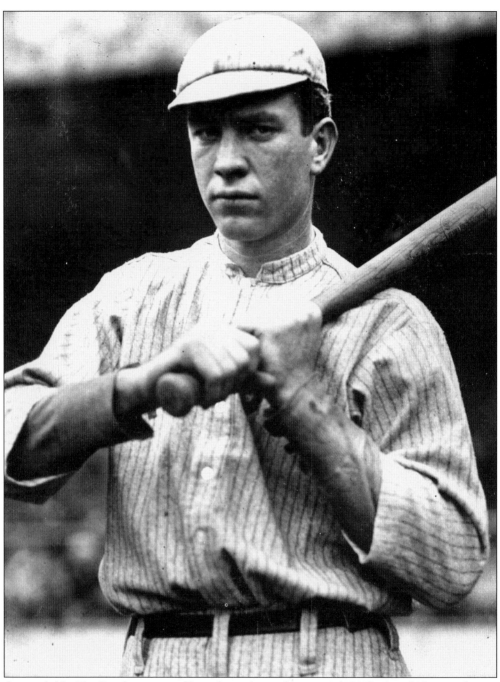

Center fielder Tris Speaker, pictured here during his rookie season (1908), played 22 major-league seasons, compiling a .344 lifetime batting average. Speaker's estimable skills as a hitter and outfielder earned him a place in the National Baseball Hall of Fame. To this day, Speaker is acknowledged as Boston's greatest center fielder. The Red Sox leading hitter for six consecutive seasons (1910–1915), Speaker was named the league's most valuable player in 1912, then known as the Chalmers Award. His prize was a four-door Chalmers touring car, a $1,950 value. In 1969, Speaker was named to the Red Sox Greatest Team Ever.

Two

THE ROYAL ROOTERS

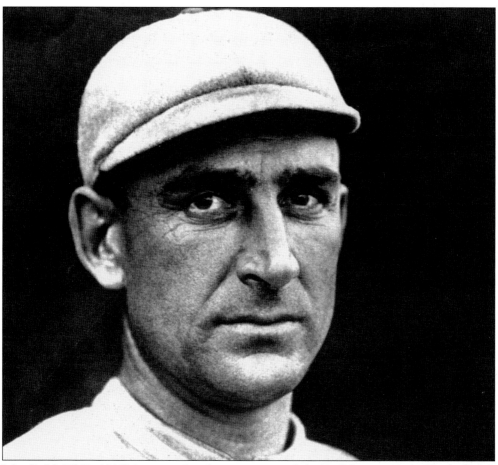

Jake Stahl (1912–1913) became the player-manager of the Red Sox in 1912. The ball club jumped from a 78-75 fifth-place finish the previous year under Patsy Donovan to a record of 105-47 and a first-place finish by a margin of 14 games over the second-place Washington Senators. Stahl also contributed as the team's regular first baseman, with 60 runs batted in and a .301 average. Stahl had been away from baseball in 1911 but decided to return to the game under Red Sox owner James McAleer.

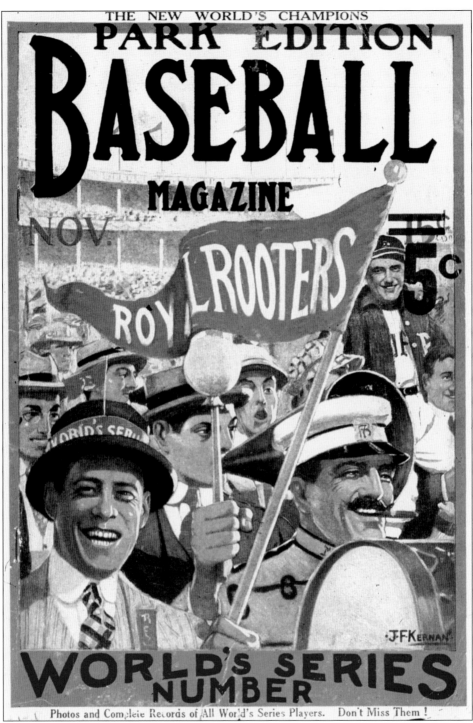

The loyal followers of the Boston American League team became known as the "Royal Rooters." They rapidly gained the reputation as the most rabid of any major-league fans anywhere. Under the direction of tavern owner "'Nuff Ced" McGreevy, owner of McGreevy's Third Base Saloon, the Royal Rooters were the early citizens of the Red Sox nation.

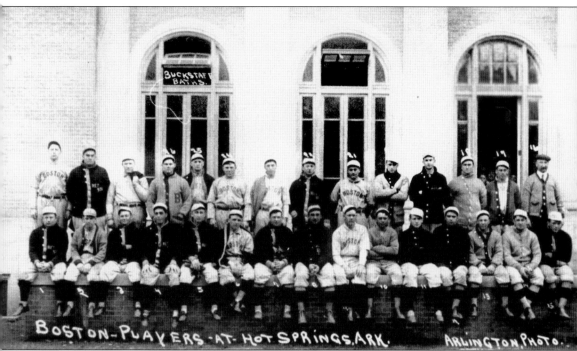

The 1912 Red Sox pose for a team photograph at spring training in Hot Springs, Arkansas. Spearheaded offensively by their brilliant center fielder Tris Speaker (222 hits, 53 doubles, 152 stolen bases, 10 home runs, 98 runs batted in, and a .383 average), who also led the league with 35 assists defensively, the Red Sox completed a remarkable turnaround. Pitching legend Smokey Joe Wood won three World Series games versus the New York Giants, including the deciding seventh over Giants mound icon Christy Mathewson. During the regular season, Wood won 34 games (against only 5 losses) to lead the American League. The win total remains a Red Sox team record 90 years later.

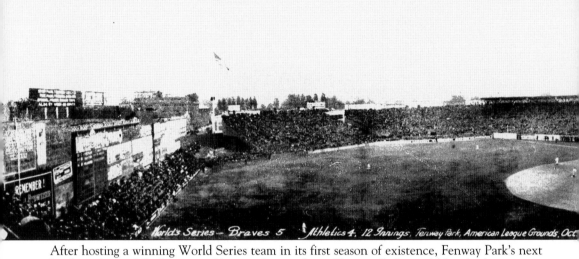

World's Series – Braves 5 Athletics 4, 12 Innings, Fenway Park, American League Grounds, Oct.

After hosting a winning World Series team in its first season of existence, Fenway Park's next brush with the fall classic would come 2 years later. Fenway Park would be the host venue for Rabbit Maranville's "Miracle Braves" showdown with the Philadelphia Athletics in the

Harry Lord (1907–1910) was Boston's regular third baseman for two seasons (1908 and 1909). His best offensive year was 1909, when he batted .311, driving in 31 runs and scoring 85. He moved on to the Chicago White Sox halfway through the 1910 season.

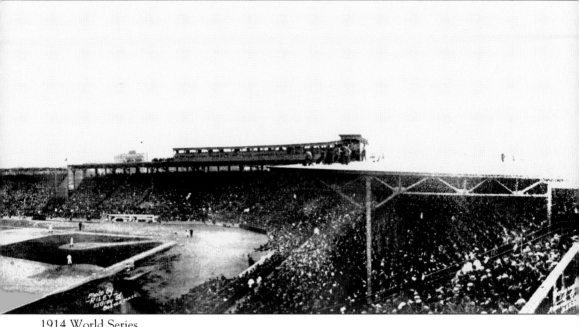

1914 World Series.

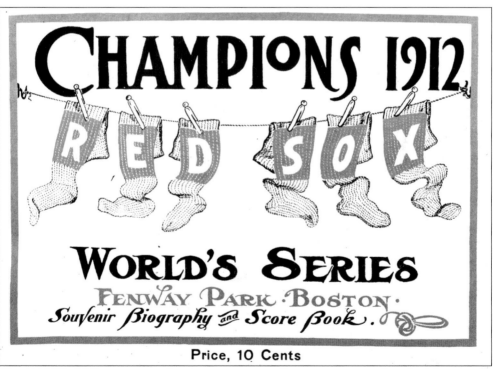

The 1912 World Series scorecard commemorates an all-time great triumph in Red Sox annals. The world championship was made even sweeter by the victory coming against John McGraw's New York Giants. The Giants, the National League champions, had refused to play the Red Sox, the American League champions, in 1904.

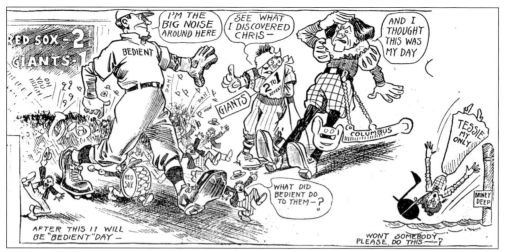

Hugh Bedient (1912–1914) enjoyed quite a memorable rookie season in a Red Sox uniform in 1912. An 18-9 regular-season record was followed up with a 0.50 ERA in 18 World Series innings. Bedient allowed a total of only 10 hits in the series.

Pictured is a souvenir pennant of the Red Sox banner season in 1912. The 105 wins remains the most in team history.

In three of the seven World Series games, Bedient matched up with and outpitched New York's future Hall of Famer Christy Mathewson, a 12-year veteran. Bedient gave up just three hits in a 2-1 complete game victory over Mathewson and the Giants in a pivotal fifth game.

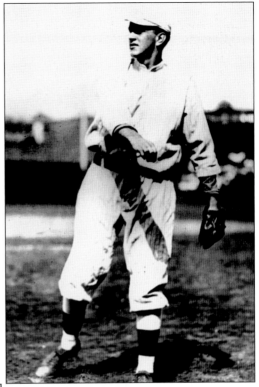

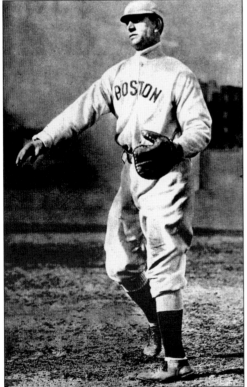

Jake Stahl was a Red Sox player on three separate occasions. After breaking in with the 1903 club, Stahl spent four seasons in Washington before returning to the Red Sox for the 1909 and 1910 seasons. He managed half of the 1913 season before being fired under suspicion of undermining team president James McAleer. Stahl would not return to the game again.

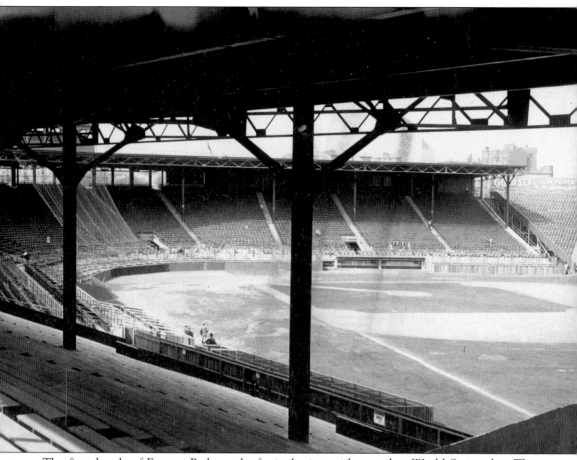

The first decade of Fenway Park was by far its busiest with regard to World Series play. The ballpark hosted Red Sox World Series action in 1912, 1915, 1916, and 1918, along with the Braves "visit" for the 1914 fall classic.

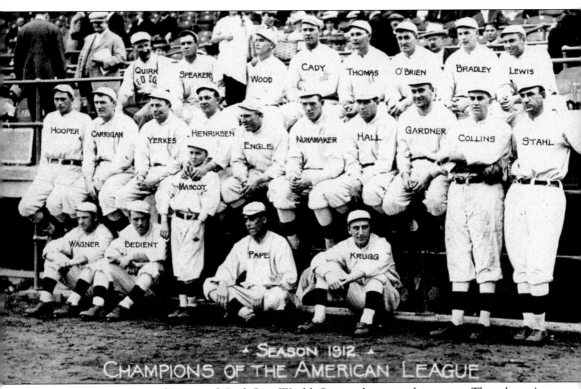

SEASON 1912
CHAMPIONS OF THE AMERICAN LEAGUE

The 1912 team was the second Red Sox World Series championship team. The players' winning share was a lucrative $4,024 apiece. The Boston American League club was a perfect five for five in its World Series appearances from 1903 to 1918. The Red Sox have not won a World Series since then. In their four subsequent series appearances—1946, 1967, 1975, and 1986—they lost in seven games.

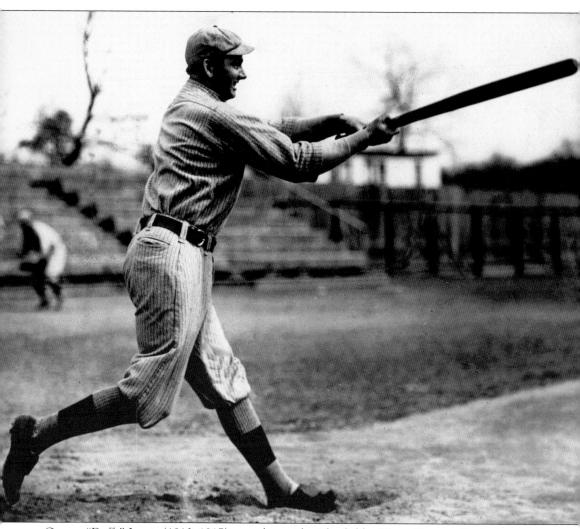

George "Duffy" Lewis (1910–1917), together with right fielder Harry Hooper, flanked center fielder Tris Speaker in one of baseball's all-time greatest outfield trios. Lewis earned his offensive reputation as a clutch hitter by leading all hitters on both sides in batting during the 1915 (.444) and 1916 (.353) Red Sox World Series victories. He was the starting left fielder for eight seasons, and the 10-foot-wide, 10-foot-deep embankment that existed near the left-field wall in Fenway Park from 1912 to 1933 became known as "Duffy's Cliff" because of Lewis's expert ability at navigating the precarious terrain. Lewis compiled a .284 lifetime average.

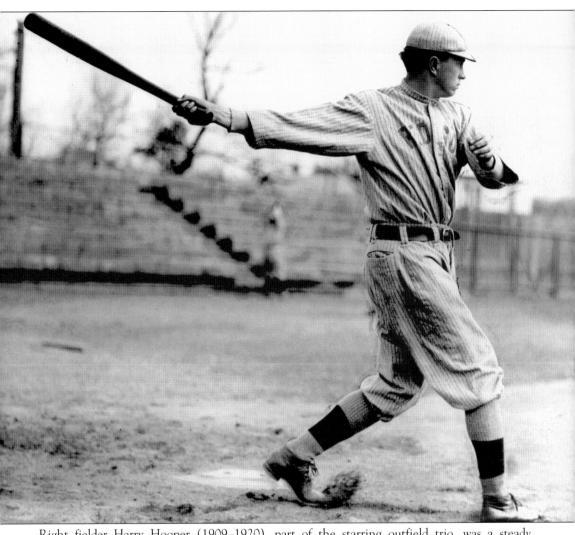

Right fielder Harry Hooper (1909–1920), part of the starring outfield trio, was a steady all-around performer (a .281 career batting average) throughout his 17-year major-league career. He earned selection to the National Baseball Hall of Fame in 1971. A rarity among ball players of his era, Hooper had an engineering degree from St. Mary's College.

The Red Sox outstanding outfield of, from left to right, Duffy Lewis, Tris Speaker, and Harry Hooper played a major role in the team's 1912 and 1915 world championship seasons. As a unit, the trio all batted over .300 in 1911 and averaged .290 in their three World Series appearances. During their five-year Boston tenure, one of the three (most often Speaker) led the team in home runs, runs batted in, and batting average 14 of 15 possible times.

This sheet music dates from 1907. Celebrated in song, the Red Sox outfield of Duffy Lewis, Tris Speaker, and Harry Hooper were held in extremely high esteem by the Boston fans of the day.

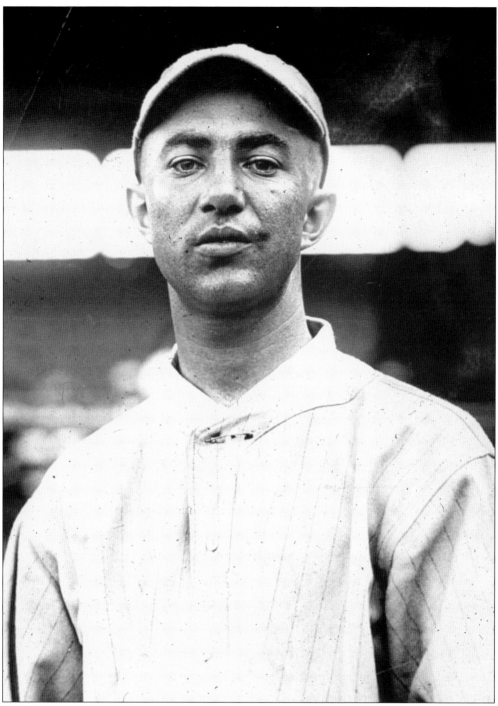

Everett "Deacon" Scott (1914–1921) was the anchor of the Red Sox infield for eight seasons. A steady, slick fielding shortstop, he was selected best fielder at his position for six consecutive years (1916–1921). He set a major-league record for durability, playing in 832 consecutive games, a record later broken by Lou Gehrig. Noted for his often sensational play in the field, Scott was a member of three world championship teams: 1915, 1916, and 1918.

Dave Shean (1918–1919) was the starting second baseman on the last Red Sox world championship team in 1918. He batted .264 and drove in 34 runs. Shean hailed from Ware, Massachusetts, and made the final stop of his nine-year career as a member of the Red Sox. He also played for the Boston Braves, among five other major-league clubs.

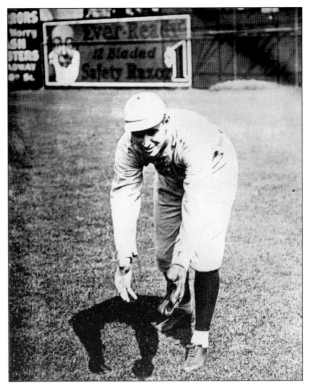

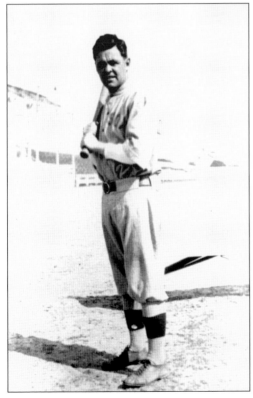

Steve Yerkes first appeared in a Red Sox uniform as a rookie in 1909. He became the team's starter at shortstop in 1911, batting .279 and driving in a career-best 57 runs. Yerkes shifted to second base for the next two seasons before departing for Pittsburgh of the Federal League in 1914.

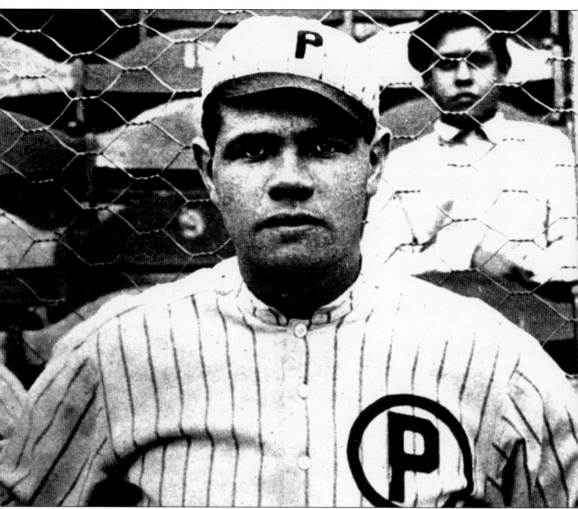

George Herman "Babe" Ruth, shown when he was with the Providence team, was a 19-year-old pitcher with the International League's Orioles in 1914. The young left-hander was signed away by Red Sox owner Joe Lannin along with right-handed pitcher Ernie Shore and catcher Ben Egan for between $20,000 and $25,000.

Three

THE BABE

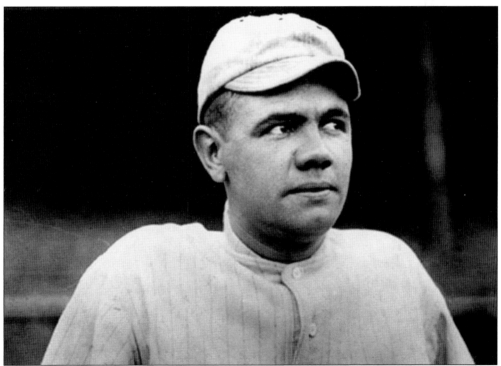

Babe Ruth is pictured as a rookie pitcher. Ruth started his first game for the Red Sox on July 11, 1914, when he was 19 years old. He gave up five hits in six innings before being knocked out of the game in the seventh, when the Indians touched the Babe for three singles. Newspaper accounts focused on Ruth's "natural delivery, fine control, and a curve ball that bothers the batsmen." Overall, Ruth pitched only 23 innings the remainder of the season for the Red Sox. He finished with a 2-1 record and a 3.91 ERA.

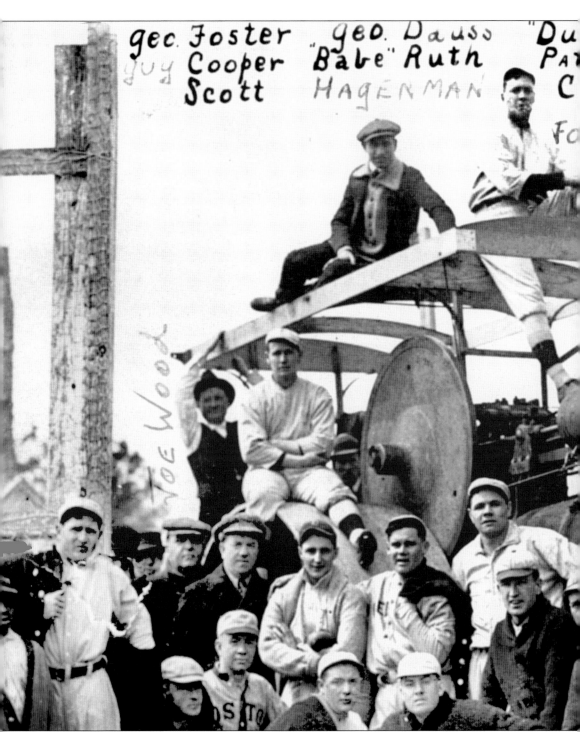

gec. Foster geo. Dauss "Du
guy Cooper "Babe" Ruth Pat
Scott HAGERMAN C
 Fo

JOE WOOD

After a one-year hiatus in Redondo Beach, California, in 1911, the Red Sox returned to Hot Springs, Arkansas, in 1912 for spring training. The site coincided with the team's ascent to dynasty of the decade in major-league baseball. While at Hot Springs, the Red Sox captured the American League pennant and world championship four of the next seven years.

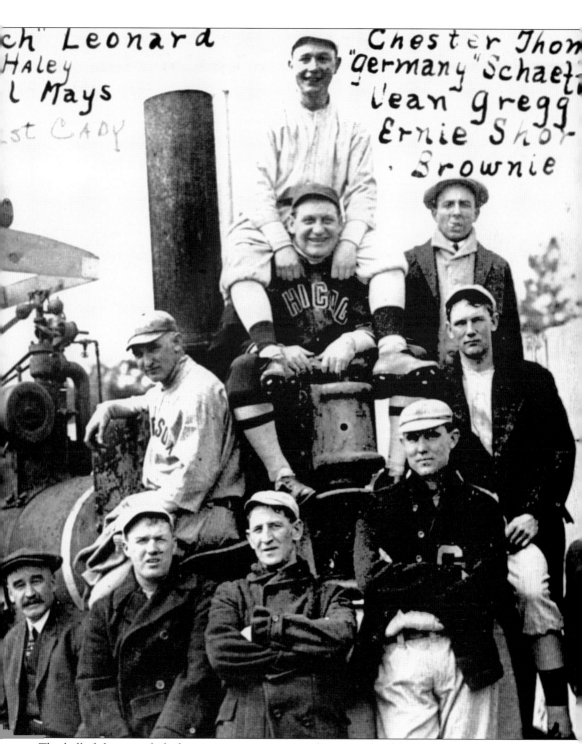

The ball club again shifted its training site in 1919 (Tampa, Florida) before returning to Hot Springs for the third and final time for the 1920–1923 period. The Red Sox have never again trained in Arkansas—or won a World Series.

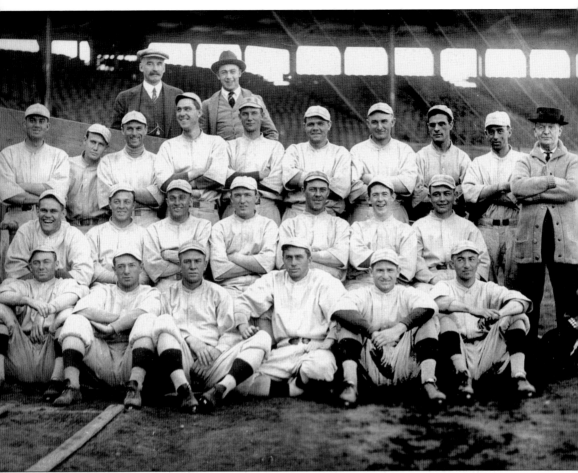

The 1915 Red Sox (101-50) outfought Ty Cobb's Detroit Tigers down the stretch to win the American League pennant by a two-and-a-half-game margin. Pitching and defense were the key elements for a Boston team that reeled off a 24-5 streak beginning in late August. The depth of the Red Sox pitching staff was impressive. Hurlers Rube Foster (19-8), Ernie Shore (18-8),Babe Ruth (18-8), Dutch Leonard (15-7), and Smokey Joe Wood (15-5) gave the club five pitchers with 15 or more victories. By contrast, only center fielder Tris Speaker hit over.300 (.322) among the team's regular players, although the young pitching phenomenon nicknamed Babe hit four home runs in just 92 at-bats to lead the team in that category.

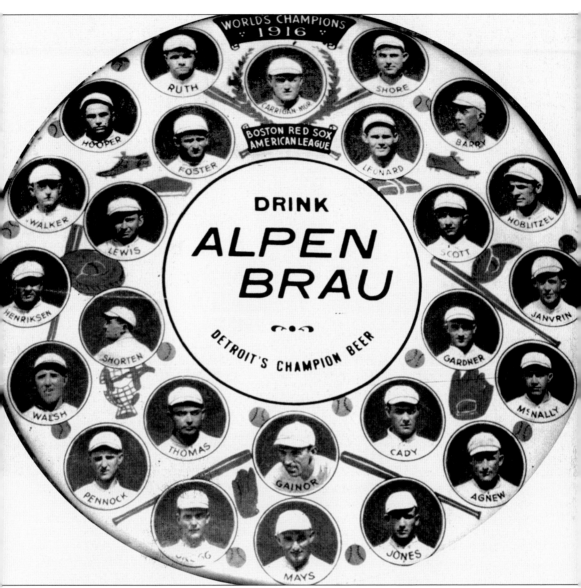

The Red Sox home World Series games against the Philadelphia Phillies were relocated to Braves Field, newly opened for the 1915 season. The superior pitching of the Red Sox led to a four-games-to-one series victory over the Philadelphia Phillies. Rube Foster won games two and five. Pictured on this pin is the 1916 world championship team.

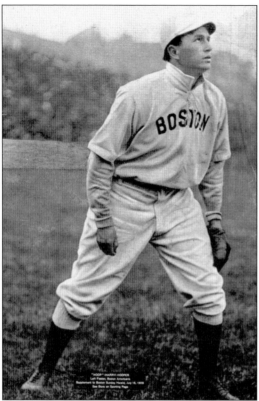

Harry Hooper is shown fielding. There was no disputing the right fielder's considerable defensive ability. In game eight of the 1912 World Series, his miraculous bare-handed catch in deep right center field at Fenway Park robbed New York Giant second baseman Larry Doyle of a potential game-breaking home run.

Carl Mays began his 15-year major-league career with the 1915 Red Sox. After a respectable debut (5-5, 2.60 ERA), Mays went on to win 62 games the next three seasons. His 21-13, 2.21 ERA ledger established him as the ace of the 1918 staff. He pitched two complete game victories in the 1918 World Series, including a 2-1 three-hitter in the deciding sixth-game victory over Chicago.

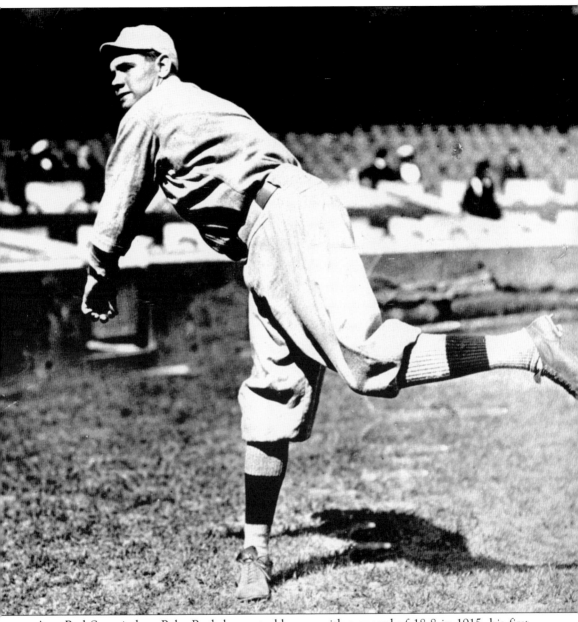

As a Red Sox pitcher, Babe Ruth began to blossom with a record of 18-8 in 1915, his first full season in Boston. Ruth did not pitch and batted only once as a pinch hitter in his first World Series.

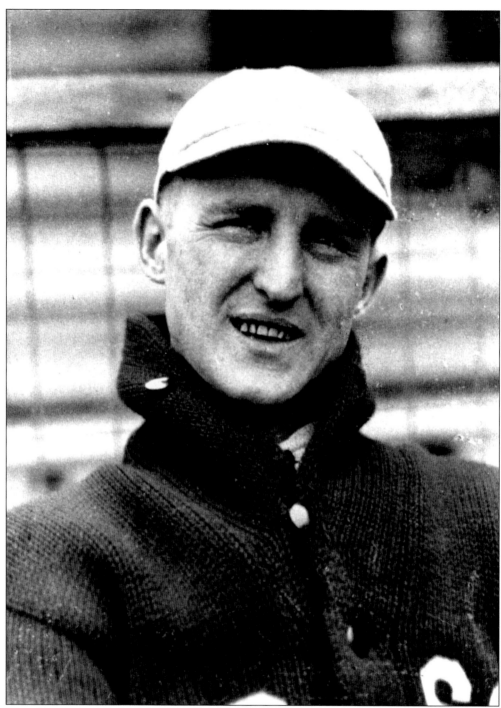

The already pitching-rich Red Sox acquired future Hall of Famer Herb Pennock from the Philadelphia Athletics in 1915. Pennock went on to compile a 59-59 record for Boston between 1915 and 1922. A New York Yankee from 1923 to 1933, the "Knight of Kennett Square" won 165 games as a key member of the Yankees' first era of dominance. Pennock was a career-perfect 5-0 in World Series play for the pinstripes.

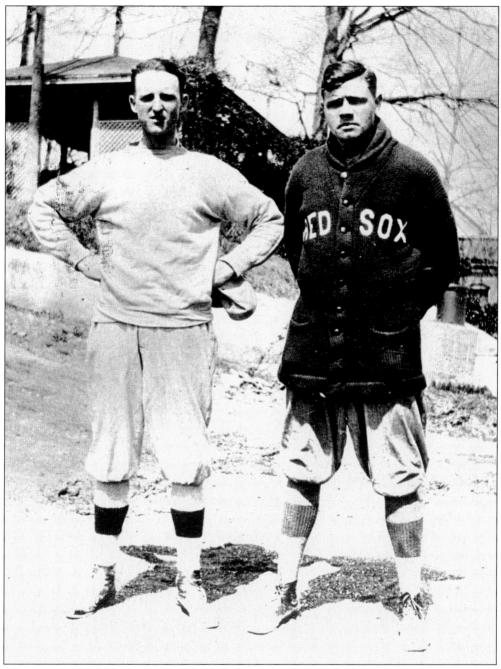

A 21-year-old Herb Pennock (left) is shown here with 20-year-old Babe Ruth at spring training in Hot Springs, Arkansas, in 1915.

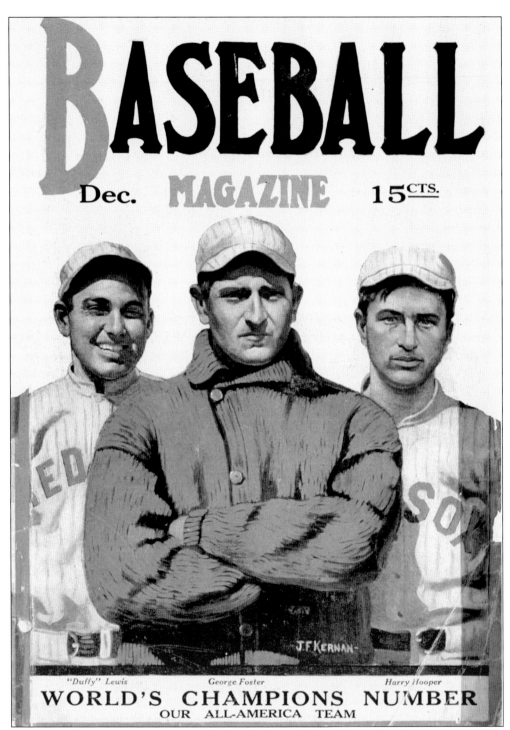

BASEBALL

Dec. MAGAZINE 15 CTS.

J.F.KERNAN

"Duffy" Lewis George Foster Harry Hooper

WORLD'S CHAMPIONS NUMBER
OUR ALL-AMERICA TEAM

As the dominant team of the era, the Red Sox received their share of media attention. After the Red Sox World Series triumph over Philadelphia, the popular *Baseball* magazine featured this December 1915 cover, with pitching ace Rube Foster flanked by two thirds of the Red Sox outfield—left fielder Duffy Lewis (left) and right fielder Harry Hooper.

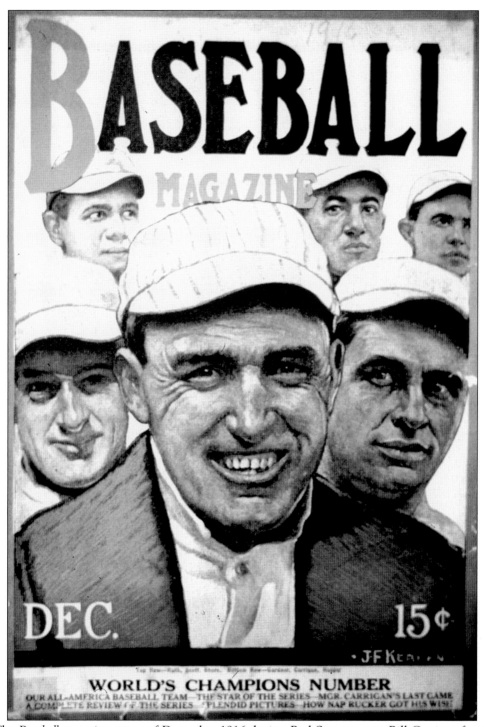

The *Baseball* magazine cover of December 1916 depicts Red Sox manager Bill Carrigan front and center, with his charges in the background. The Red Sox had repeated as world champions, defeating the Brooklyn Dodgers four games to one in the 1916 World Series.

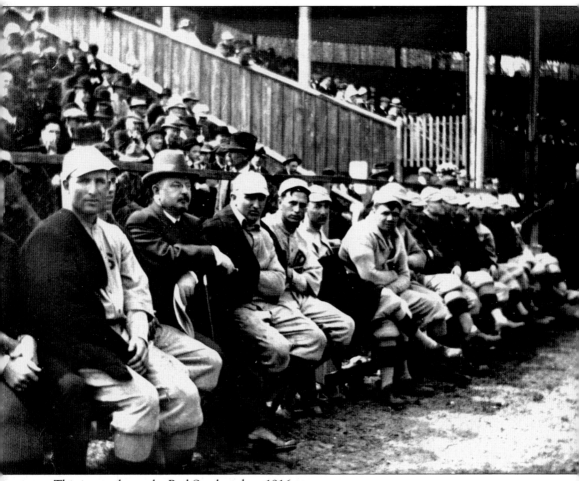

This image shows the Red Sox bench c. 1916.

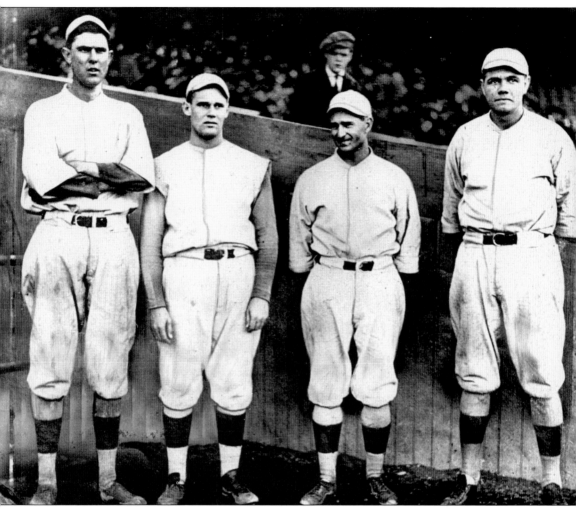

Pictured is the 1917 starting pitching rotation, Ernie Shore (13-10), Babe Ruth (24-13), Dutch Leonard (16-17), and Rube Foster (8-7). The pitchers could not match those of the White Sox. Foiled in their attempt for a third-straight American League pennant, the Red Sox (90-62) finished second, nine games behind Chicago.

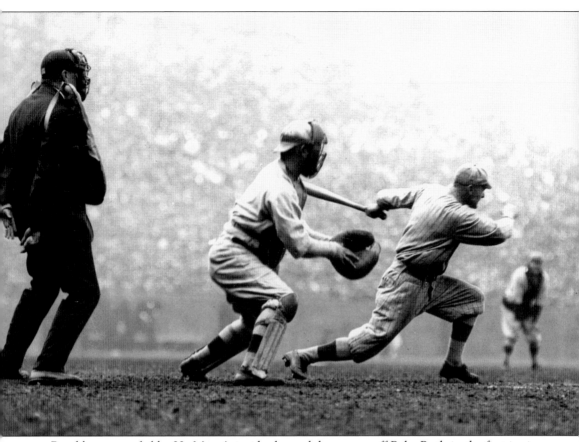

Brooklyn center fielder Hy Myers's inside-the-park home run off Babe Ruth in the first inning of game two of the 1916 World Series accounted for the Dodgers' only run in a 14-inning 2-1 marathon loss to the Red Sox. Ruth went the distance for the win, pitching all 14 innings at Fenway Park while limiting the Dodgers to just six hits.

The Red Sox outstanding pitching depth again proved to be a huge determining factor in the 1916 World Series. Ernie Shore (2-0), Babe Ruth (1-0), and Dutch Leonard (1-0) all turned in impressive mound performances as the Red Sox rolled to a four-games-to-one series victory. Shore spun a complete-game three-hitter in the decisive fifth game, a 4-1 Red Sox victory. Shown (right) is a 1916 World Series program. Duffy Lewis (below), the Red Sox leading hitter in the series (.353), crosses first base safely in the first inning of game two.

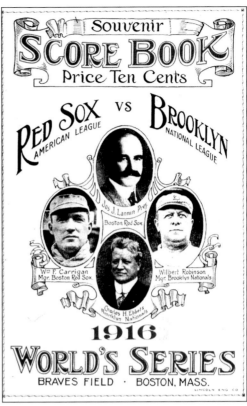

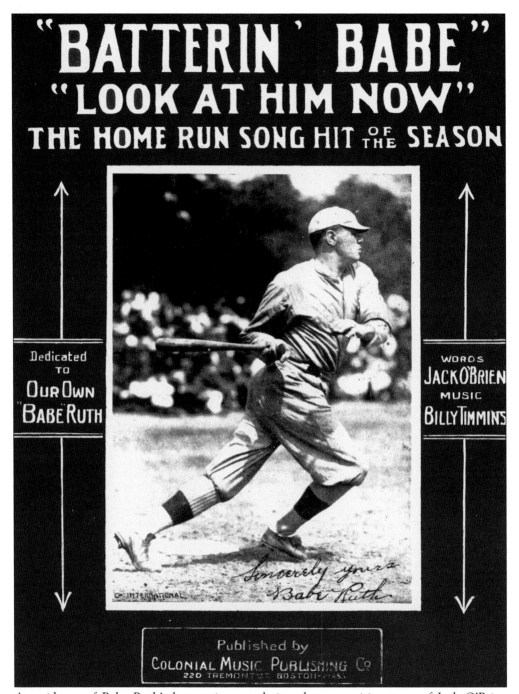

As evidence of Babe Ruth's burgeoning popularity, the songwriting team of Jack O'Brien and Billy Timmins composed a song called "Battering Babe, Look at Him Now" (1919) in dedication to the budding slugger's long-ball prowess.

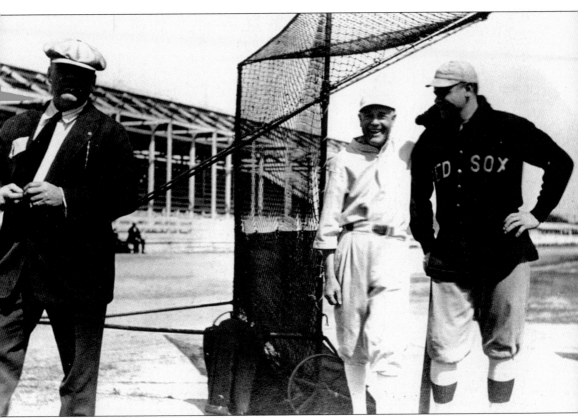

Getting ready to win back the pennant lost to Chicago in 1917, the Red Sox prepare at spring training in 1918. Hanging out by the batting cage, from left to right, are pitcher Babe Ruth, future Red Sox manager Hugh Duffy (1921–1922), and then Red Sox manager Ed Barrow (1918–1920). Hall of Fame outfielder Duffy was a Boston favorite during his playing days with the Boston National League club (1892–1900).

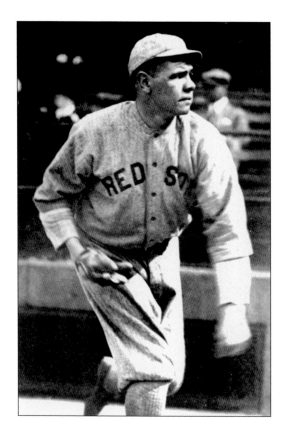

Babe Ruth quickly developed into one of the game's dominant pitchers, overall compiling a pitching record of 89-46 for the Red Sox between 1914 and 1919.

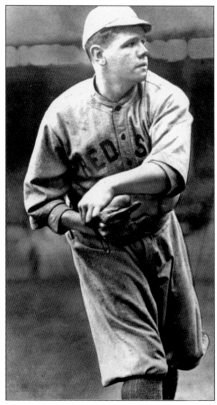

Ruth enjoyed relaxing at a farm he purchased in Sudbury, a rustic town west of Boston. He is shown (below) in a pensive pose during his early Boston days.

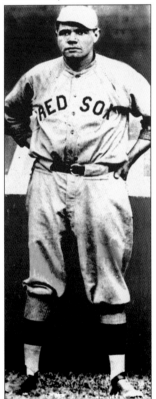

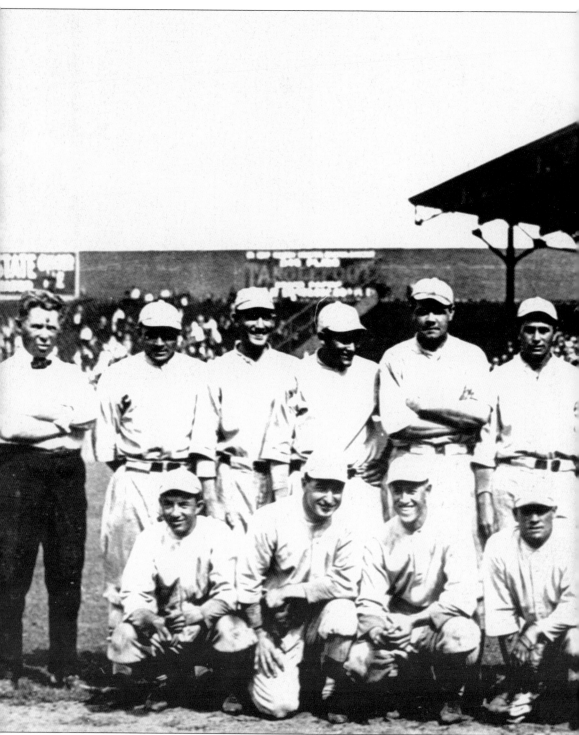

The 1918 Red Sox were the last Boston World Series champions. They finished three-and-a-half games ahead of the Cleveland Indians for the American League pennant and were matched up with the Chicago Cubs in the World Series. Babe Ruth (back row, fifth from

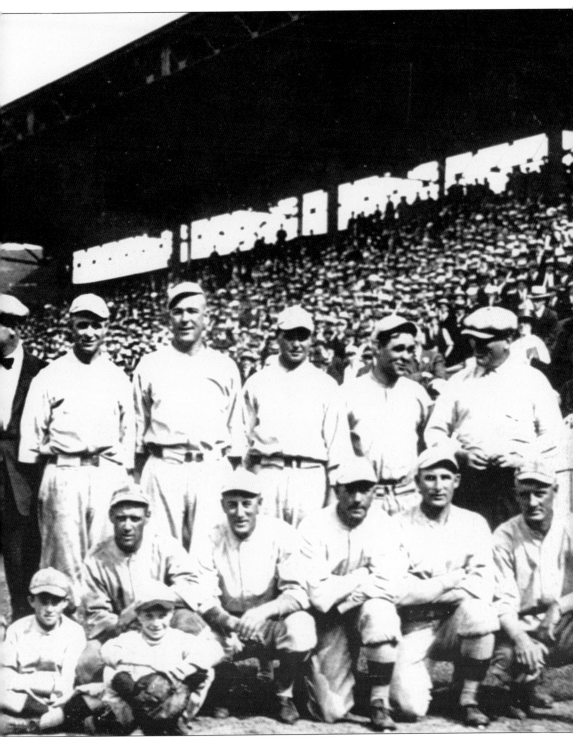

the left), appearing in 72 games (59 outfield, 13 first base) as an everyday player, led the team in hitting (.300) and runs batted in (64)—and all of baseball, with 11 home runs. On the mound, Carl Mays (not pictured) was the established ace (21-13, 2.21 ERA).

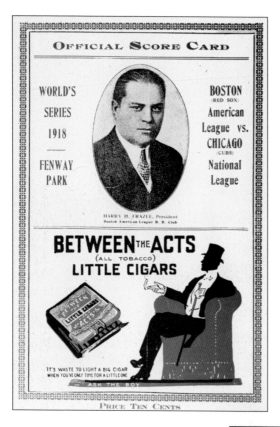

In the 1918 World Series, Babe Ruth and Carl Mays each won two games, which were highlighted by the Babe's 1-0 six-hit shutout in game one and Mays's 2-1 three-hit masterpiece in game six. Ruth established a World Series record of $29^2/3$ shutout innings before being scored upon in game four. The streak extended back to game two in the 1916 series. Catcher Wally Schang (.444) topped all Boston regulars in batting average as he drove in the deciding run in game three and scored the winning run in game four. The biggest and most unlikely Red Sox World Series hero turned out to be George Whiteman, a journeyman 35-year-old outfielder. Whiteman made several outstanding defensive plays, none more spectacular than an acrobatic eighth-inning catch off the Cubs' Turner Banks's sinking line drive to help preserve Carl Mays's 2-1 decisive game-six triumph. Pictured is a 1918 World Series scorecard.

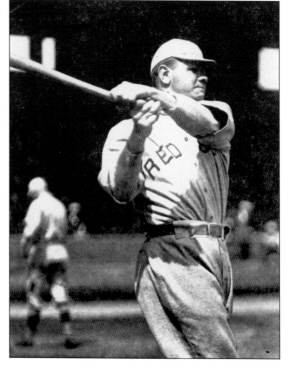

In 1919, his last season with the Red Sox, Babe Ruth leaned more toward the field than the mound. As Boston's regular left fielder, he hit 29 home runs and drove in 112 runs (to lead the league in both categories), while batting .322 overall.

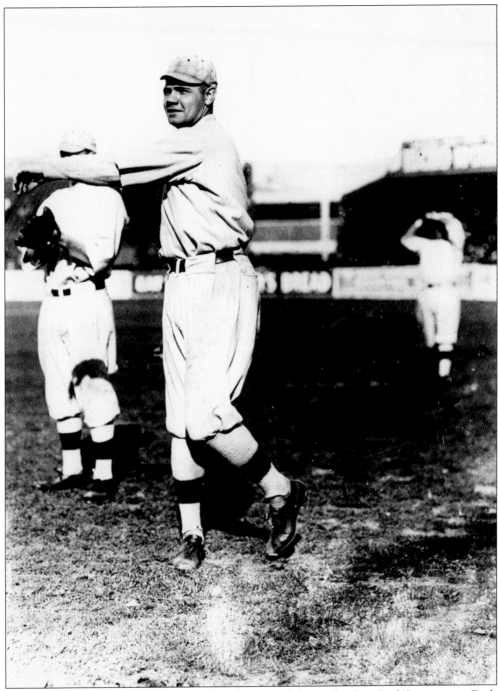

Babe Ruth warms up before a game. On the mound during his last Red Sox season, Ruth compiled a 9-5, 2.97 ERA log for a severely slumping Red Sox team that finished sixth (66-71), 20$^{1}/_{2}$ games behind the first-place Chicago White Sox.

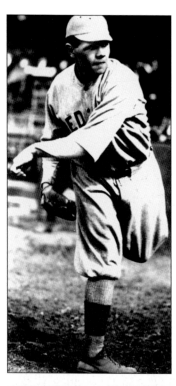

Babe Ruth on the mound became a rare sight during the rest of his career. As a Yankee from 1920 to 1934, he pitched only 31 more innings.

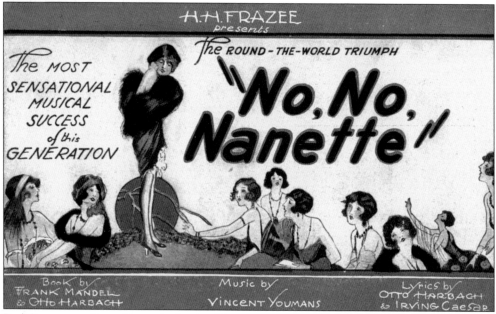

H.H. FRAZEE
presents

The ROUND-THE-WORLD TRIUMPH

The MOST SENSATIONAL MUSICAL SUCCESS of this GENERATION

"No, No, Nanette"

Book by FRANK MANDEL & Otto Harbach

Music by Vincent Youmans

Lyrics by Otto Harbach & Irving Caesar

Red Sox owner Harry Frazee had gained his reputation in the world of Broadway theatrical production. The musical hit *No, No, Nanette* followed the sale of Babe Ruth to the New York Yankees. The popular legend of a cash-strapped Frazee selling Ruth to finance the musical has been recently exposed as inaccurate in the book *Red Sox Century*. The sale of Ruth was really about the Babe's reluctance to continue pitching while also being a regular outfielder and his subsequent bitter contract dispute with Frazee.

Four

THE BORING TWENTIES

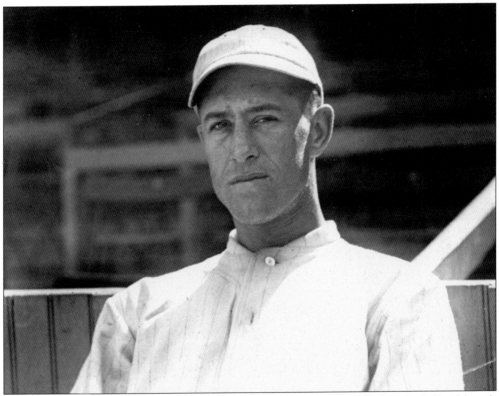

Pitcher Leslie "Bullet Joe" Bush earned his nickname by virtue of his blinding fastball. Although just 15-15 overall for the Red Sox during the pennant-winning 1918 season, Bush set a club record with five 1-0 victories. He also led the staff in ERA, with a 2.11 mark. His best season for victories was 1921, with 16. He moved on to New York in 1922 and won 62 games the next three seasons for the pinstripes.

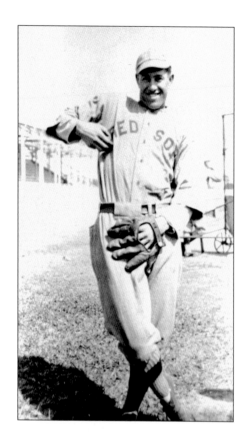

Leslie Bush broke in with the Philadelphia Athletics in 1912 and finished with the Athletics in 1928, posting a career record of 196-181 and a 3.51 ERA.

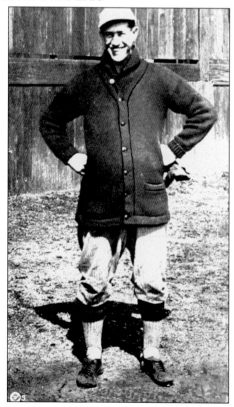

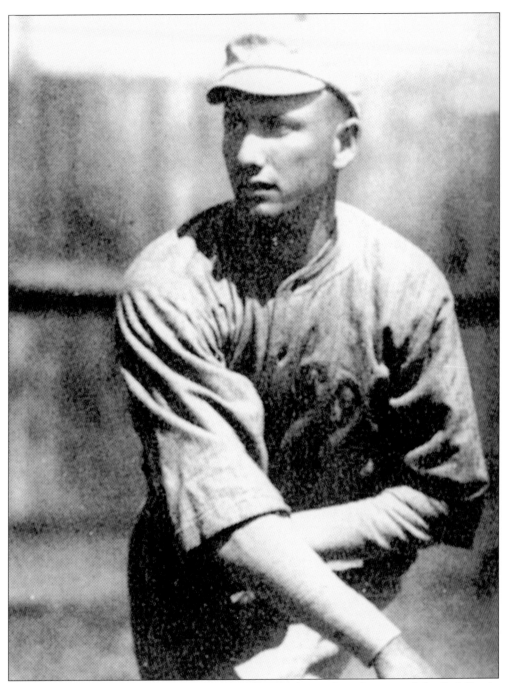

Pitcher Samuel Pond "Sad Sam" Jones was well named regarding the state of the Red Sox in the years immediately succeeding their world championship season in 1918. Jones finished his first full season on the mound for Boston that year with a record of 16-5 and 2.25 ERA, leading the league in winning percentage (.762). The next three years proved to be a roller-coaster ride for Jones and the Red Sox, losing 20 games in 1919 and winning 23 in 1921. In 1922, Jones followed the well-trodden path from the Fens to the Bronx, pitching for the Yankees from 1922 to 1926, winning 21 in 1923 with his trademark deceptive motion.

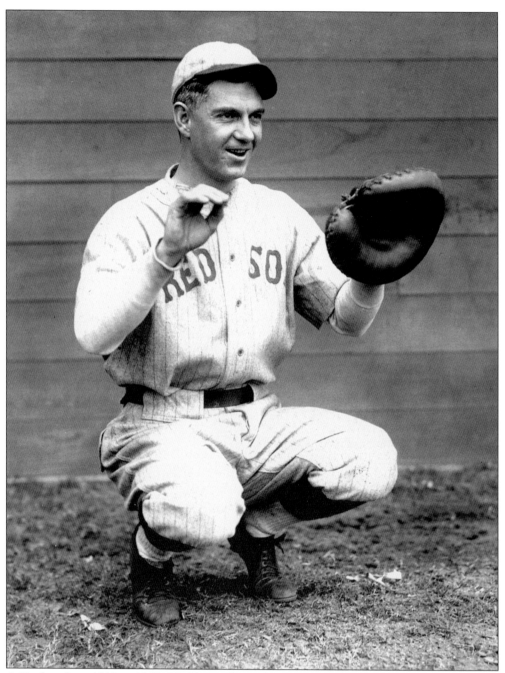

A Yankee from 1917 to 1920, Muddy Ruel was the Red Sox starter behind the plate for two seasons (1921 and 1922). Ruel hit .277 with 43 runs batted in (1921) and .255 with 28 runs batted in (1922). Ruel moved on to the Washington Senators between 1923 and 1930 and returned to the Red Sox briefly in 1931.

John Phelan "Stuffy" McInnis
(1918–1921) was a former member of
the Philadelphia Athletics
"million-dollar infield." The first
baseman brought his patented long
defensive stretch to the Red Sox
world championship team in 1918. An
outstanding defensive first baseman,
he made one error in 1,652 chances
(.999) during his final year with the
Red Sox. The native of Gloucester
twice batted over .300 for Boston
(.305 in 1919 and .307 in 1921).
In the 1918 World Series, he had a
game-winning hit in one game and the
deciding run in another. He coached
the Harvard University baseball team
after his major-league career.

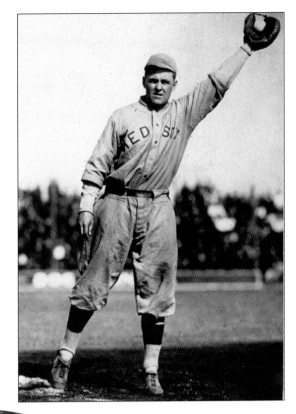

Wally Schang (1918–1920)
was the batting leader
among Red Sox players
in the 1918 World
Series, going four for
nine (.444). Catcher
Schang split time
behind the plate
with Sam Agnew
for the last Red Sox
world champions,
hitting .244 with
20 runs batted in.
He batted over .300
the next two seasons
(.306 in 1919 and
.305 and 1920), driving
in 106 runs. He was yet
another Red Sox player
that called Yankee Stadium
home after leaving Fenway
Park, catching for the Yankees
from 1921 to 1925.

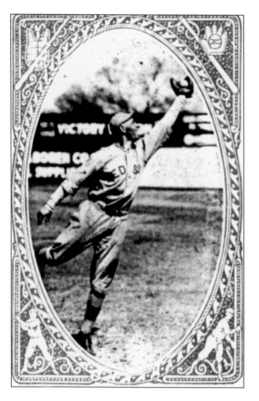

Outfielder Mike Menosky (1920–1923) finished his nine-year major-league career with the Red Sox, hitting an even .300 in 1921 and driving in a career-best 64 runs in 1920.

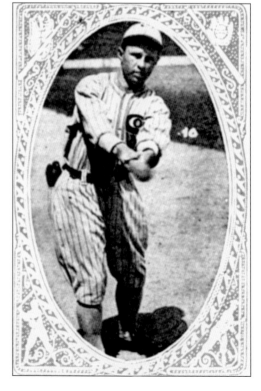

Nemo Leibold (1920–1923) hit .306 with 30 runs batted in as the Red Sox starting center fielder (1921). His stay in Boston was relatively brief, however, as he headed to Washington early in the 1923 season, finishing his 13-year major-league career with the Senators.

Catcher Al "Roxy" Walters (1912–1923) came over from the Yankees and spent five seasons as a Red Sox catcher, mainly splitting time with Wally Schang and then Muddy Ruel. Walters's best season at the plate was 1923 (.250). He finished his career playing sparingly for the Cleveland Indians (1924–1925).

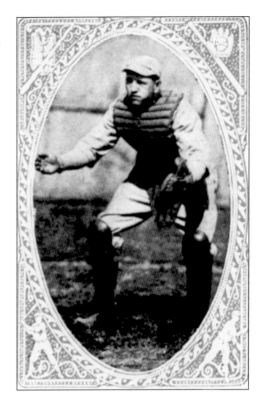

Del Pratt (1921–1922) never played in a World Series in his 13 major-league seasons. A St. Louis Brown for his first six years in the big leagues, Pratt was too early (1918–1920) to be a member of the great Yankee teams and too late (1921–1922) to play for any of the Red Sox best. He was a second baseman adept with the bat, six times averaging .300 and batting below .275 only twice in his career. He also drove in 966 career runs, twice knocking in 100, including a league-leading total of 103 in 1916 with St. Louis.

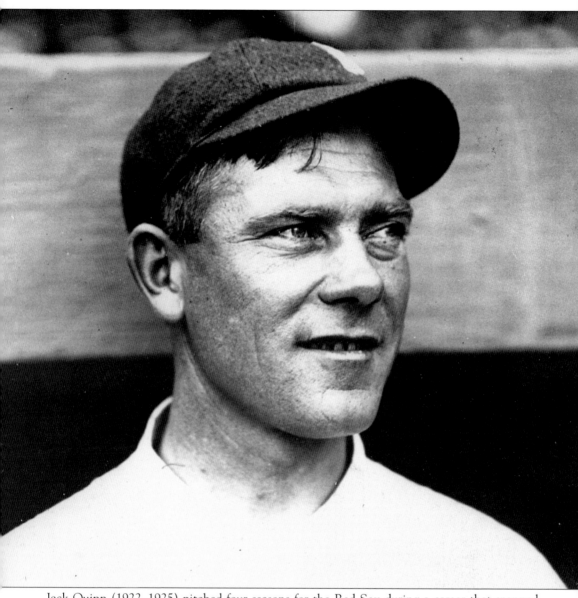

Jack Quinn (1922–1925) pitched four seasons for the Red Sox during a career that spanned a remarkable 23 years (1909–1933). Quinn compiled a 45-53 record in Boston, pitching for some dreadful Red Sox teams. The Red Sox finished last in three of the four seasons Quinn spent in Boston.

Pitcher Ben "Baldy" Karr (1920–1923) broke into the majors as a 26-year-old rookie with the 1920 Red Sox. His best season in Boston was 1921 (8-7, 3.67 ERA), including a league-best five wins in relief. Karr went on to pitch three more years for the Cleveland Indians (1925–1927).

Pitcher Elmer Myers (1921–1922) finished an eight-year major-league career with the Red Sox. He was 8-12 with a 4.87 ERA in his only full season as a starting pitcher for Boston.

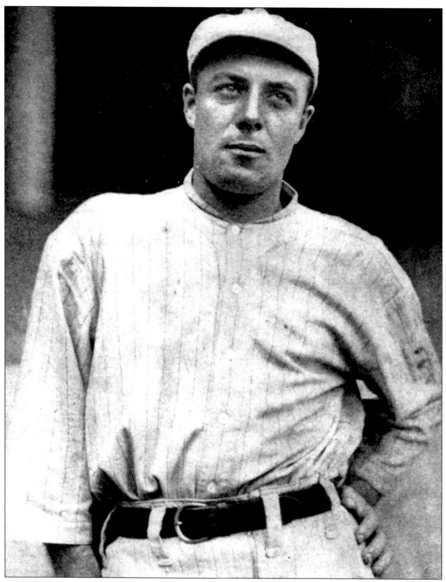

George "Tioga" Burns (1922–1923) came over from the Cleveland Indians to become the regular first baseman for the Red Sox. He put together two solid offensive seasons: a team-leading 12 home runs to go along with 73 runs batted in and a .306 average (1922), and a 7–home run, team-leading 82 runs batted in, with a .328 average (1923). Defensively, Burns has the distinction of completing an unassisted triple play on September 14, 1928, against the Cleveland Indians. He and shortstop John Valentin (who did the same on July 8, 1994) are the only two Red Sox players to accomplish the feat.

Pitcher Howard Ehmke (1923–1926) came to Boston from the Detroit Tigers and won 20 games for the cellar-dwelling 1923 Red Sox team. The following year, Ehmke pitched a league-leading 315 innings for another last-place Boston team. After losing 20 games for a third-straight eighth place in 1925, Ehmke moved on to the Philadelphia Athletics, pitching for that team from 1926 until the end of his 15-year big-league career in 1930.

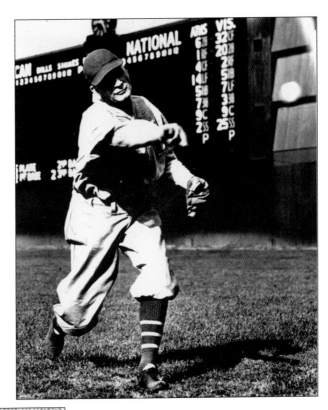

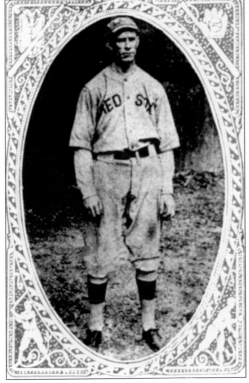

A local boy from Charlestown, John Francis "Shano" Collins (1921–1925) spent the first 11 years of his 16-year major-league playing career in the Windy City before changing his socks from white to red in 1921. Collins played as the regular right fielder for two seasons for the Red Sox. His best season was his first in Boston, with 4 home runs, 65 runs batted in, and a .286 batting average. He came back to manage the Red Sox to a sixth-place finish in 1931.

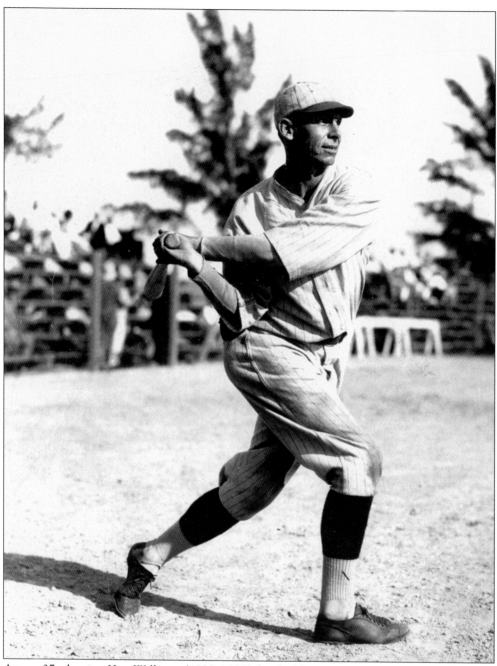

At age 37, slugging Ken Williams (1928–1939) finished his 14-year major-league career with the Red Sox. As the team's starting left fielder in 1928, Williams hit .303, with 8 home runs and 67 runs batted in. He played sparingly (139 at-bats) in his final season but still managed to hit .345.

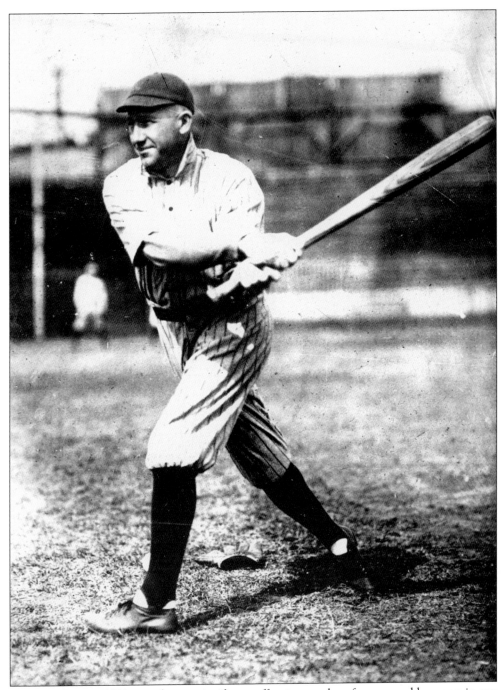

Del Pratt (1921–1922) posted some significant offensive numbers for a second baseman in any era during his two years with the team. Pratt followed up a campaign of 5 home runs, 100 runs batted in, and a .324 batting average in 1922. He completed a 13-year major-league career with the Detroit Tigers (1923–1924).

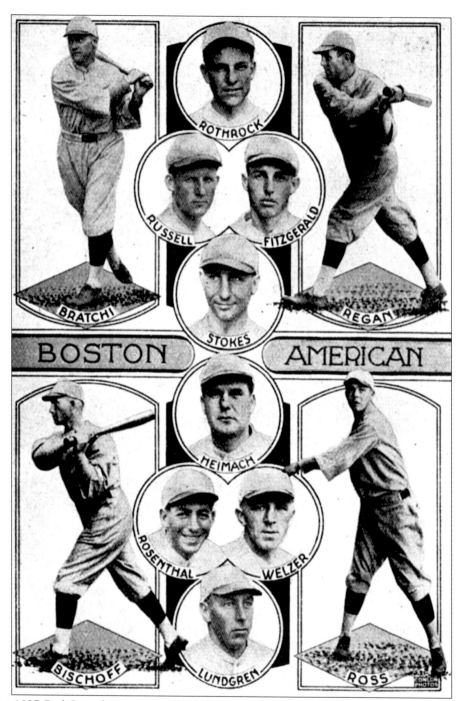

The 1927 Red Sox, shown in a collage that appeared in the *Spalding Guide*, continued the tailspin that began in 1919, the year after their last World Series championship. Three seasons below .500 (1919–1921) began a spiral that sank the Red Sox into last place for eight of the nine seasons from 1922 to 1930. The 1927 team lost 100-plus games (51-103) for a third straight year, finishing an all-time worst 59 games behind the "Murderer's Row" 1927 New York Yankees.

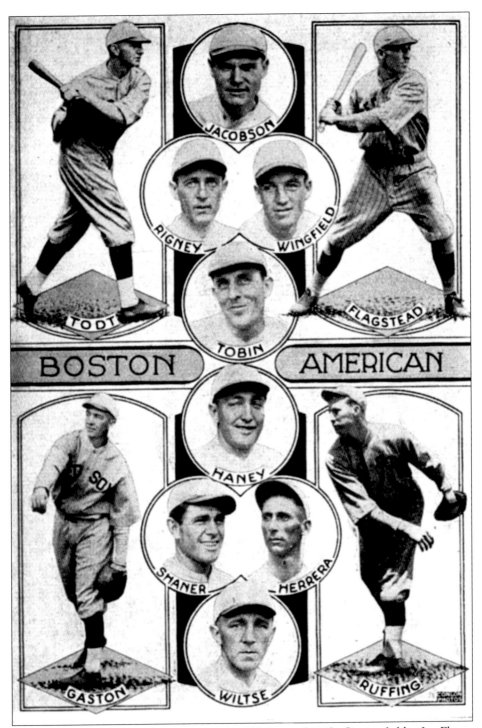

Right fielder Jim Tobin was the team's only .300 hitter (.310). Center fielder Ira Flagstead drove in 69 runs to lead the team. On the mound, William "Slim" Harris won a team-best 14 games while losing a league-highest 21. Overall, 1927 was not a year that Red Sox fans would want to remember. This collage of the 1927 team appeared in the *Spalding Guide*.

Pitcher "Deacon Danny" MacFayden (1926–1932) broke in as a 20-year-old with the Red Sox. The best Boston season for the Cape Cod native (North Truro) was a 16-12 and 4.02 ERA ledger in 1931. MacFayden also led the American League in shutouts, with four in 1929. he went on to the Yankees during the 1932 season and later pitched twice for the Boston Braves (1936–1939), as well as in his final season in 1943.

Catcher Charlie Berry (1928–1932) did the bulk of the catching for the Red Sox from 1929 to 1931. His best season was 1931, batting .283 with 6 home runs and 49 runs batted in. Berry departed for the White Sox in 1932.

First baseman Phil Todt (1924–1930) spent all but 62 games of his eight-year major-league career with the Red Sox. He led the 1927 team in home runs with 6, a tenth of Babe Ruth's league-leading total of 60. Todt's best all-around offensive year was 1925, when he hit .278, with 11 home runs and 75 runs batted in.

In 1924, Ike Boone (1923–1925) became the starting right fielder for the Red Sox. During his two Boston seasons, Boone posted some impressive numbers, leading the team across the board in all three major offensive categories: 13 home runs, 95 runs batted in, and a .333 batting average. He followed up with a solid 9 home runs, 68 runs batted in, and a .330 batting average in 1925. He resurfaced with the Chicago White Sox (1927) before finishing his career with Brooklyn (1930–1932).

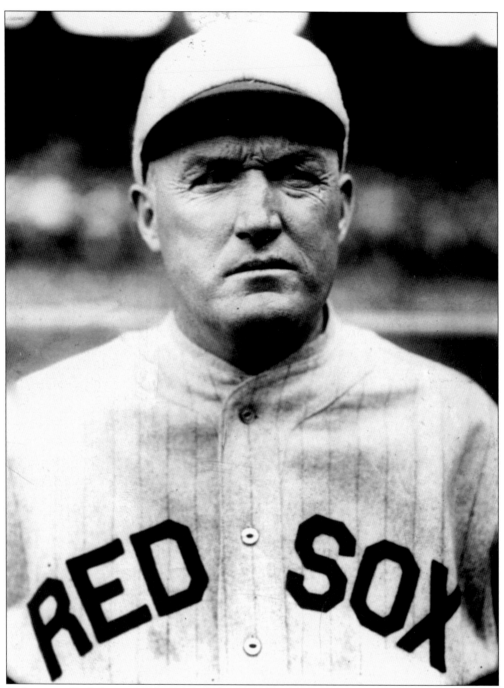

A desperate Red Sox ownership turned the managerial reins back to "Rough Bill" Carrigan in 1927. The Red Sox skipper (1913–1916) for back-to-back World Series victories in 1915 and 1916, Carrigan returned to a disastrous situation. Rough's second tour of duty in the Red Sox dugout (1927–1929) proved to be just that—rough. Boston finished dead last all three seasons, going a combined 166-295.

Five

THE 1930S: Floundering On

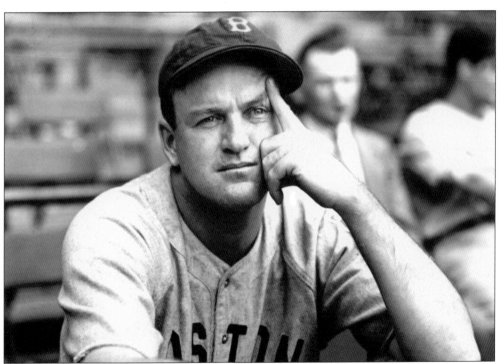

Joe Cronin (1935–1945) is one of only five Red Sox players to have his number (4) retired by the ball club. He began his playing career with the Washington Senators in 1928 and remained the team's starting shortstop until his departure for Boston after the 1934 season. At age 26, Cronin became the manager of the Senators and promptly led them to the American League pennant in his first season as player-manager (1933). He continued as a playing manager of the Red Sox through the 1945 season. In 1946, as Red Sox manager, Cronin led the team to its first pennant in 28 years. Elected to the National Baseball Hall of Fame in 1956, he holds the distinction of being the first modern-day player to become a league president. Cronin took the managerial reins from Bucky Harris, his manager, as a rookie with the Senators.

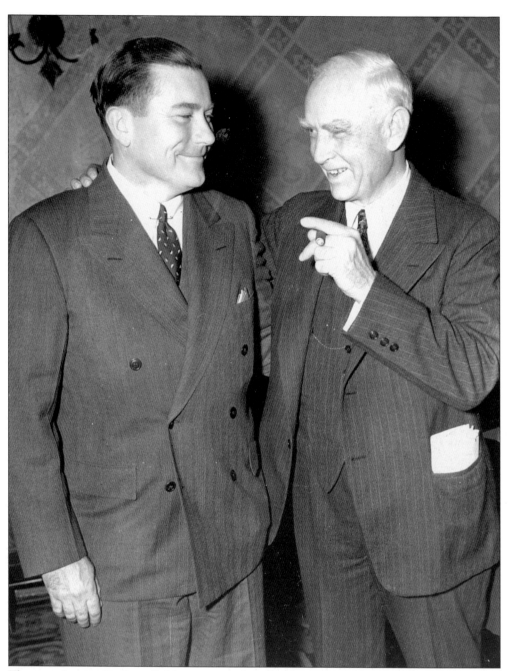

Thomas Austin Yawkey (left) is pictured with Senators owner Cal Griffith. Yawkey (1933–1976) purchased the team from J.A. Robert Quinn on February 25, 1933, four days after Yawkey's 30th birthday, and placed the team in a trust. Among Yawkey's first moves were the renovation of 22-year-old Fenway Park prior to the 1934 season and the 1935 acquisition of Hall of Fame shortstop-manager Joe Cronin from Griffith's Washington Senators. Yawkey was the adopted nephew of William Yawkey, who had previously owned the Detroit Tigers, and was the heir to a fortune made in the lumber and mining businesses. Yawkey owned the team until his death at age 73 in 1976.

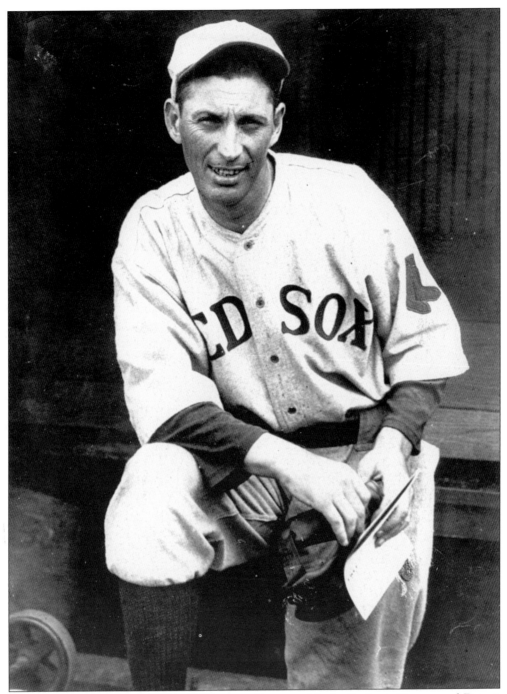

Infielder Marty McManus (1931–1933) spent 11 years with the St. Louis Browns and Detroit Tigers before joining the Red Sox late in the 1931 season. McManus played all four infield positions over the next two seasons while serving double duty as Red Sox manager, succeeding Shano Collins 57 games into the 1932 campaign. In 1933, McManus's only full season as manager and the first year of the Tom Yawkey era, the Red Sox compiled a 63-86 record and finished seventh.

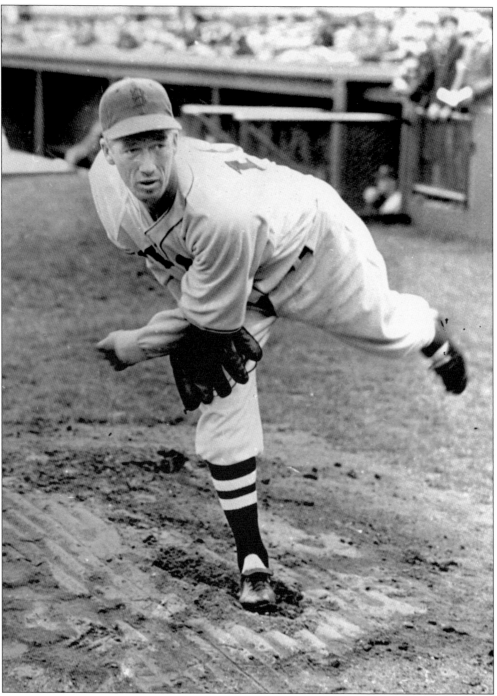

Hall of Fame hurler Robert Moses "Lefty" Grove (1934–1941) had been one of the game's premier pitchers for almost a decade with the Philadelphia Athletics (1925–1933) when owner Tom Yawkey purchased the veteran for $125,000 prior to the 1934 season.

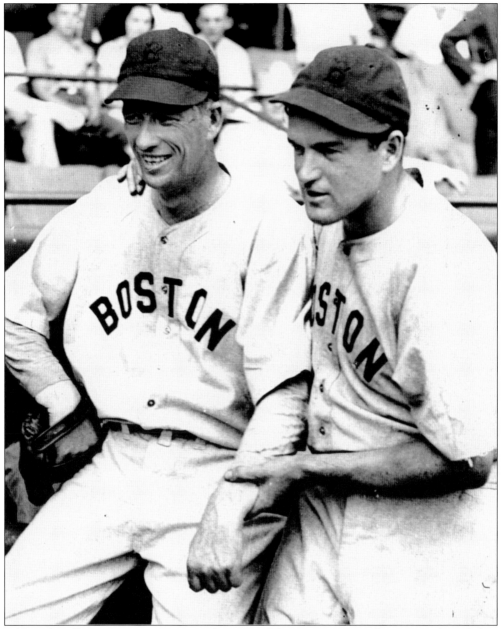

Although suffering from a sore arm at the time of the transaction, Lefty Grove rebounded to win 105 games over the next eight seasons, including his 300th and final career victory in a Red Sox uniform. He had only one 20-win season left in him (1935) but managed to lead the American League in earned run average four times during his Boston tenure. He is shown in conversation with Joe Cronin (right).

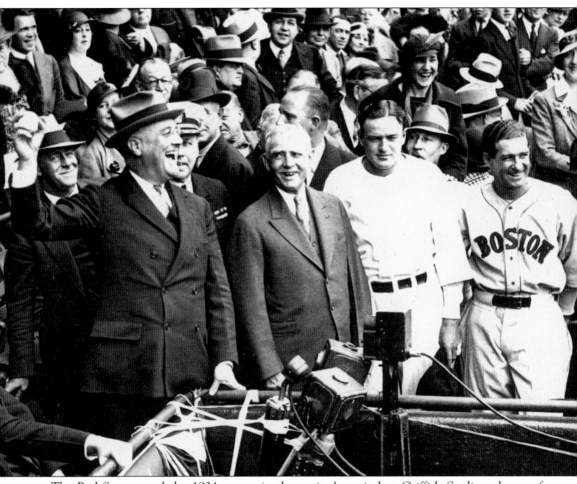

The Red Sox opened the 1934 season in the nation's capital at Griffith Stadium, home of the Washington Senators. From left to right are Pres. Franklin Delano Roosevelt, handling the chief executive duties of throwing out the game's ceremonial first ball; Cal Griffith, the Washington owner; Joe Cronin, shortstop-manager of the Senators; and Bucky Harris, the manager of the Red Sox.

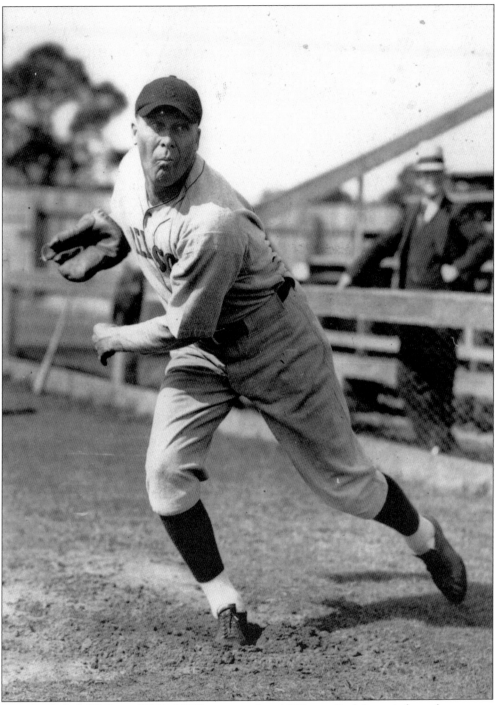

George "Rube" Walberg (1934–1937) was another 1930s-era Red Sox pitcher who spent a decade with Connie Mack's Philadelphia Athletics (1924–1933) before finishing his career in Boston. Walberg did not fare anywhere near as well as Lefty Grove, winning only 21 games (against 27 defeats) over his final four major-league seasons.

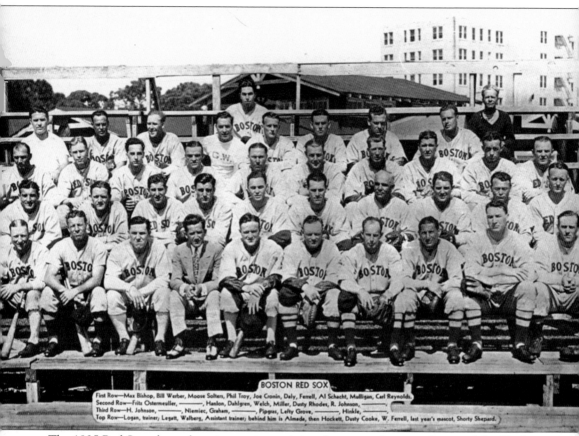

BOSTON RED SOX

First Row—Max Bishop, Bill Werber, Moose Solters, Phil Troy, Joe Cronin, Daly, Ferrell, Al Schacht, Mulligan, Carl Reynolds.
Second Row—Fritz Ostermueller, ———, Hanlon, Dahlgren, Welch, Miller, Dusty Rhodes, R. Johnson, ———,
Third Row—H. Johnson, ———, Niemiec, Graham, ———, Pipgras, Lefty Grove, ———, Hinkle, ———,
Top Row—Logan, trainer; Legett, Walberg, Assistant trainer; behind him is Almada, then Hockett, Dusty Cooke, W. Ferrell, last year's mascot, Shorty Shepard.

The 1935 Red Sox, shown here in a spring-training shot, were the second team of the Yawkey era and the first to play at the newly renovated Fenway Park. Under the direction of Joe Cronin, the former manager of the Washington Senators, Boston finished in fourth place for the second consecutive season.

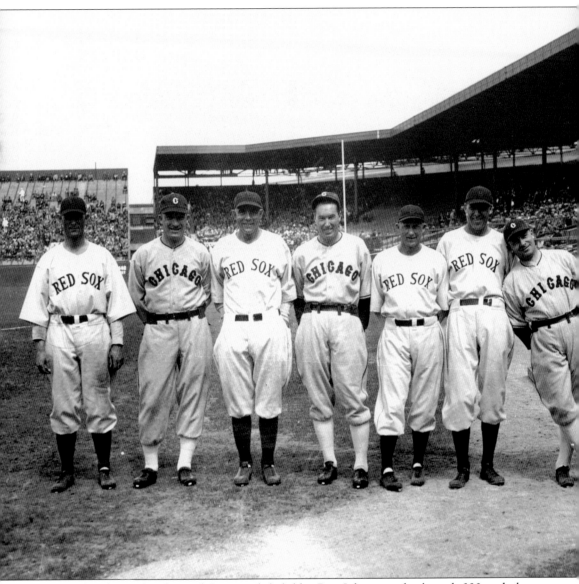

The leading hitter for the Red Sox was left fielder Roy Johnson, who batted .320 and also led the team in runs batted in, with 119. The pitching duo of former Philadelphia Athletics Lefty Grove and Rube Walberg were a disappointing 14-15 and combined for the exactly .500 (76-76) team. Pictured are members of the Red Sox and White Sox, all of whom previously represented the Philadelphia Athletics.

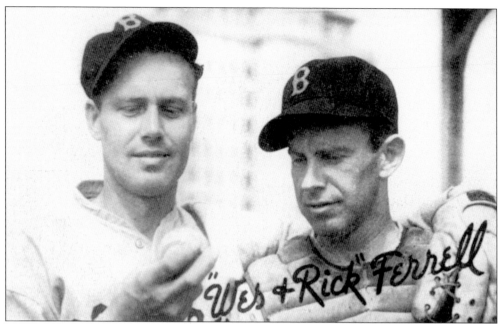

The brother battery mates Wes Ferrell (above left and below) and Rick Ferrell (above right) spent four seasons together with the Red Sox. Catcher Rick Ferrell was the first acquisition by new Red Sox general manager Eddie Collins in 1933. Pitcher Wes Ferrell (1934–1937) arrived from Cleveland in 1934. Playing catch with his brother seemed to agree with Wes, as he proceeded to compile a 62-40 overall record on the mound for the Red Sox, highlighted by a league-leading 25 wins and a remarkable 322 innings pitched in 1935.

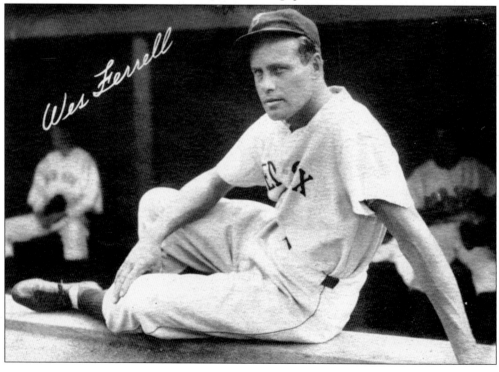

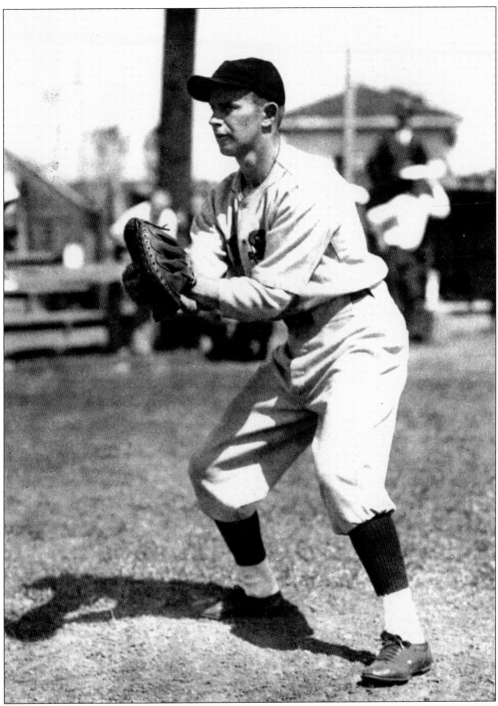

Catcher Rick Ferrell (1933–1937) had five solid all-around seasons with the Red Sox, hitting .300 while being consistently rated as one of the league's top defensive receivers.

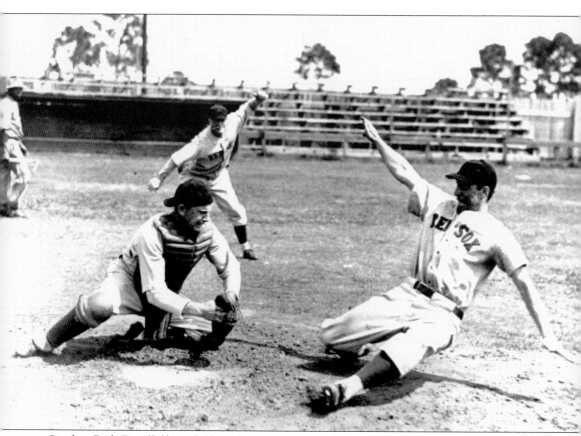

Catcher Rick Ferrell (front left) applies a tag to a rookie base runner attempting to score in spring training action.

Pictured are two Goudey chewing gum cards from 1933. Pitcher John Welch (right) (1932–1936) came over to the Red Sox from the Chicago Cubs. His top season for wins (13) was 1934, when he also pitched a career-high 206⅓ innings. Welch departed for the Pittsburgh Pirates in 1936. Left fielder Roy Johnson (below) (1932–1935) began his career with the Detroit Tigers in 1929. Johnson topped .300 as a hitter in each of his three full seasons as a Red Sox player. His best overall season was 1934, with 7 home run, 119 runs batted in, and a .320 batting average. He played for the New York Yankees (1936–1937) and then finished his career with the Boston Braves (1937–1938).

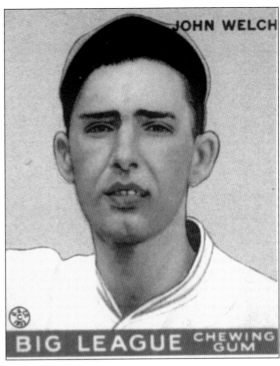

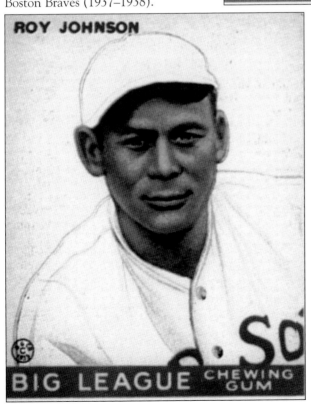

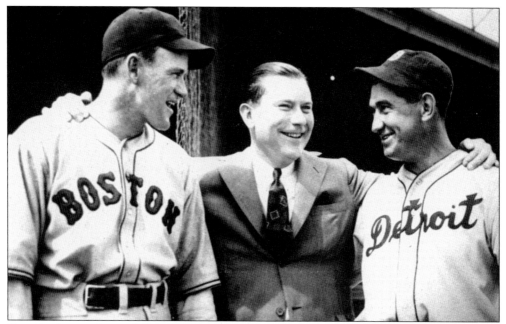

Tom Yawkey confers with Joe Cronin and Mickey Cochrane. Yawkey's purchase of Cronin from Cal Griffith (his father-in-law) for $250,000 made previous manager Bucky Harris expendable. Harris went back to Washington to manage the Senators. The game of musical managerial chairs completed, Harris, Cronin, and Cochrane would all end up in Cooperstown.

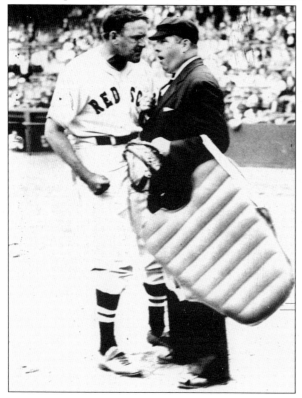

An angry Joe Cronin was not an unusual sight as the Red Sox struggled, particularly through the early part of his tenure as manager.

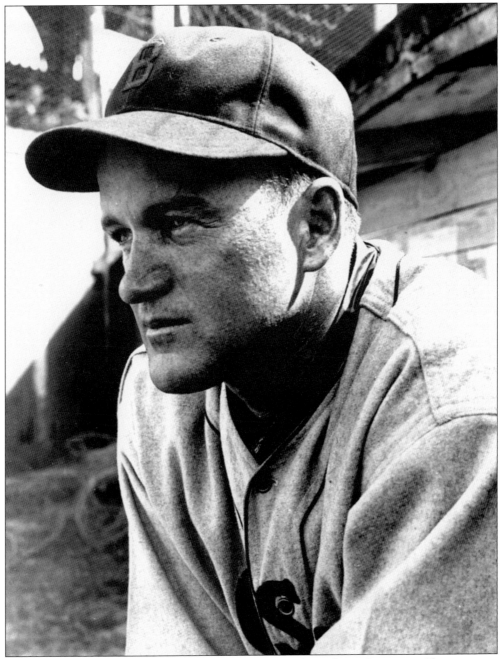

A second-place finisher four times (1938, 1939, 1941, and 1942), Joe Cronin would not manage in the World Series with Boston until 1946.

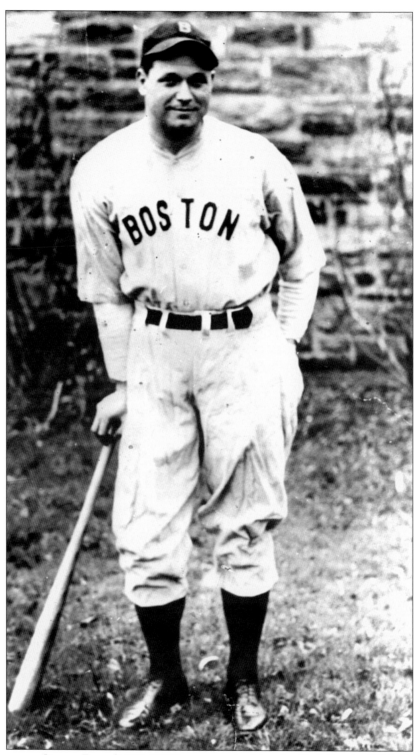

First baseman Jimmy Foxx (1937–1942) was acquired by the Red Sox in 1936 along with pitcher Johnny Marcum in exchange for two players and between $150,000 and $250,000.

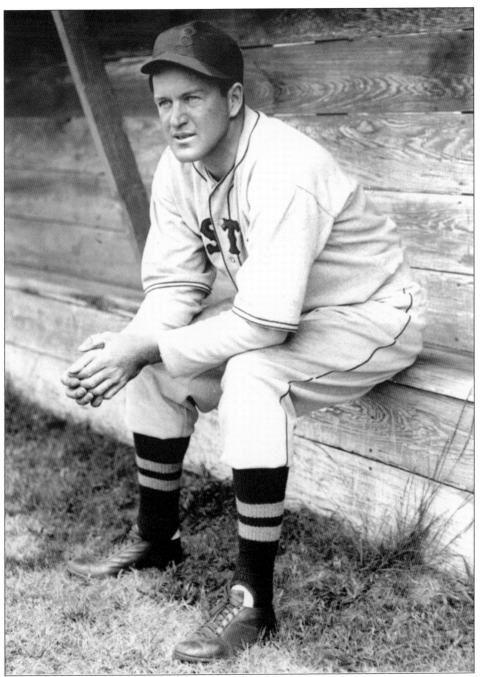

The Foxx deal was supported by manager Joe Cronin (above), but subsequent transactions created a rift between owner Tom Yawkey and Cronin, who at age 29 was not prepared to give up his shortstop position. Jimmy Foxx, a volatile slugger, hit 222 of his 534 career home runs during his six years at Fenway Park. Known as "the Beast" for his ability to terrorize American League pitchers, Foxx put up some imposing numbers in 1938: 50 home runs, 175 runs batted in, a .704 slugging percentage, and a .349 batting average (the latter three figures the American League best). The 50 home runs remains a Red Sox record.

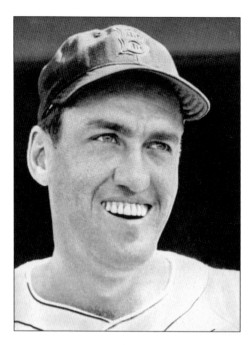

A second-generation major-leaguer, Jim Bagby Jr. (1938–1940) broke into the big leagues with the Red Sox by going 15-11 as a rookie. Bagby was a combined 15-21 the next two seasons. He spent the next five seasons with the Cleveland Indians before returning to the Red Sox to help the 1946 American League champions, the first Red Sox pennant winners in 26 years.

Pitcher Fritz Ostermuller (1934–1940), shown on a gum card from 1934, made his major-league debut with the 1934 Red Sox. Ostermuller won 59 of his 114 career victories with Boston. His best Red Sox season was 1938, when he won 13 and lost 5.

Infielder Billy Werber (1933–1936) played briefly in parts of two seasons (1930 and 1933) for the New York Yankees before coming to Boston during the 1933 season. Werber spent most of his time with the Red Sox at third base, batting .321 with a league-leading 40 stolen bases in 1934.

Infielder Eric McNair (1936–1938) was another of several players to make the trek from the Philadelphia Athletics to the Red Sox. McNair posted his best numbers for Boston in 1937 (12 home runs, 76 runs batted in, and a .292 batting average) as the regular second baseman for the Red Sox.

These 1937 Red Sox sluggers are, from left to right, shortstop Joe Cronin, first baseman Jimmy Foxx, right fielder Ben Chapman, and center fielder Doc Cramer. The 1937 team finished 80-72, in fifth place in the American League standings, 21 games behind the Yankees, but still boasted several solid offensive performers: Cronin (18 home runs, 110 runs batted in, and a .307 batting average), Foxx (36 home runs, 127 runs batted in, and a .285 batting average), Chapman (7 home runs, 57 runs batted in, and a .307 batting average), and Cramer (no home runs, 51 runs batted in, and a .305 batting average).

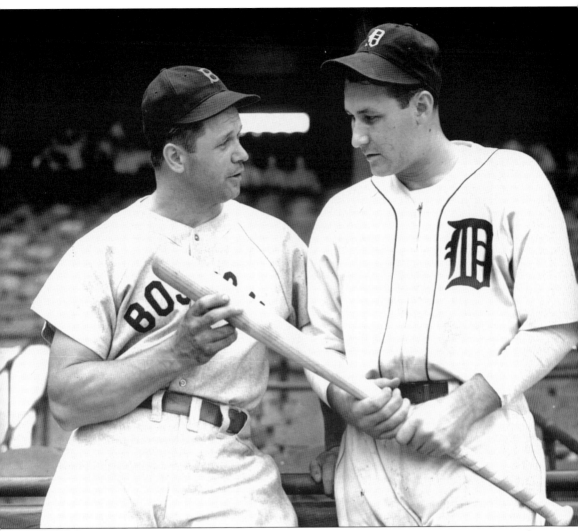

Red Sox slugger Jimmy Foxx (left) poses here with Rudy York of the Detroit Tigers. York became the power-hitting first baseman for the Red Sox and was the starting first baseman for the 1946 American League champions.

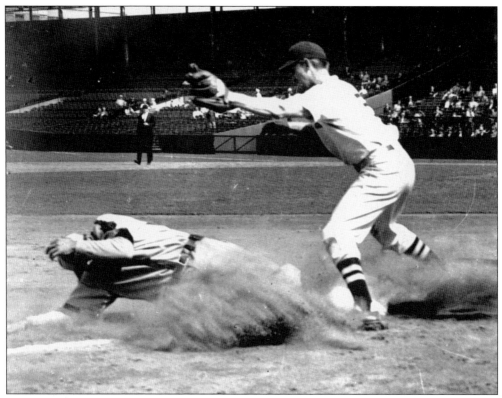

This photograph shows action at Fenway Park during the 1938 season.

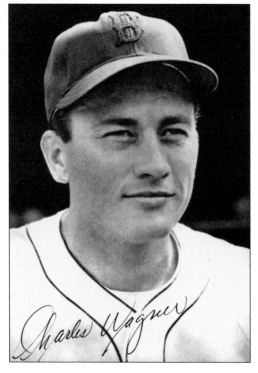

Charlie Wagner (1938–1942 and 1946) spent his entire major-league career with the Red Sox, compiling a 32-23 record. His best season was 1942 (14-11, 3.29 ERA). Nicknamed "Broadway" for his natty attire away from the park, Wagner was rookie Ted Williams's roommate on the road during the 1939 season.

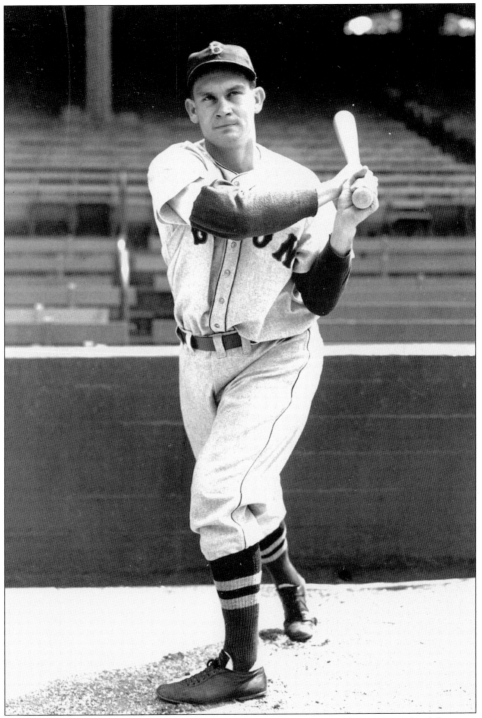

Mike "Pinky" Higgins (1937–1938) spent two seasons as Boston's starting third baseman, driving in 106 runs each season while batting .302 and .303. Higgins also had played for the Philadelphia Athletics before coming to Boston. He finished his playing career with the 1946 Red Sox, and managed the Red Sox for eight seasons (1955–1962).

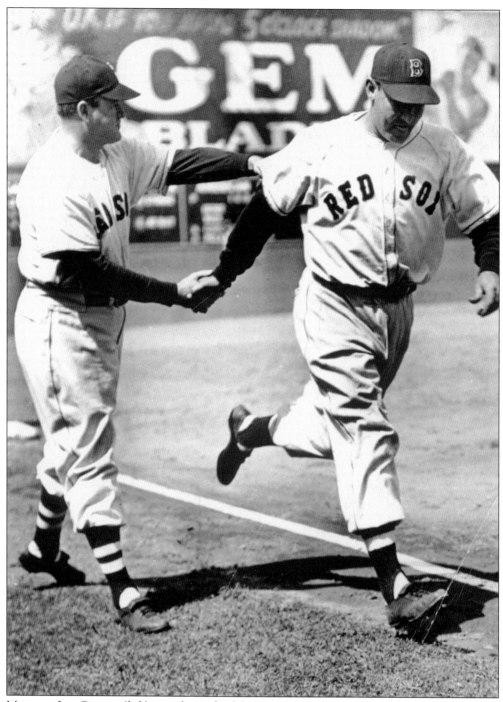

Manager Joe Cronin (left), coaching third base, sends outfielder Joe Vosmik (1938–1939) around to score. Vosmik led the league with 201 hits in 1938.

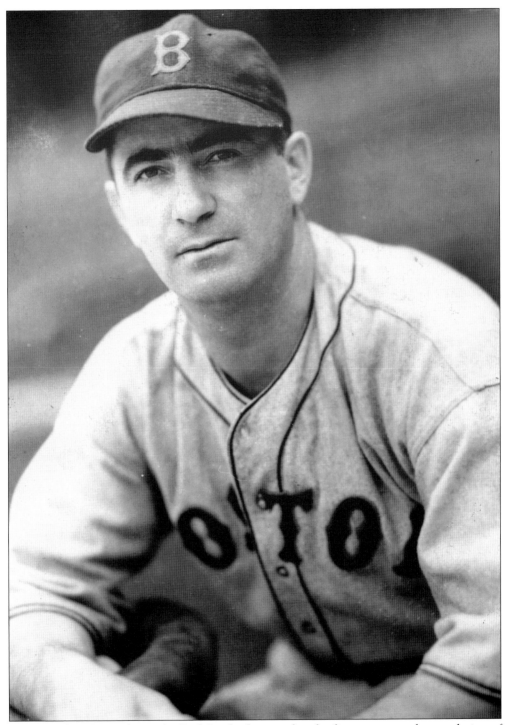

Moe Berg (1935–1939) was the Red Sox backup catcher for five seasons at the conclusion of his 15-year major-league career. The Princeton-educated Berg became noted many years later for his World War II exploits as a spy for the Allies.

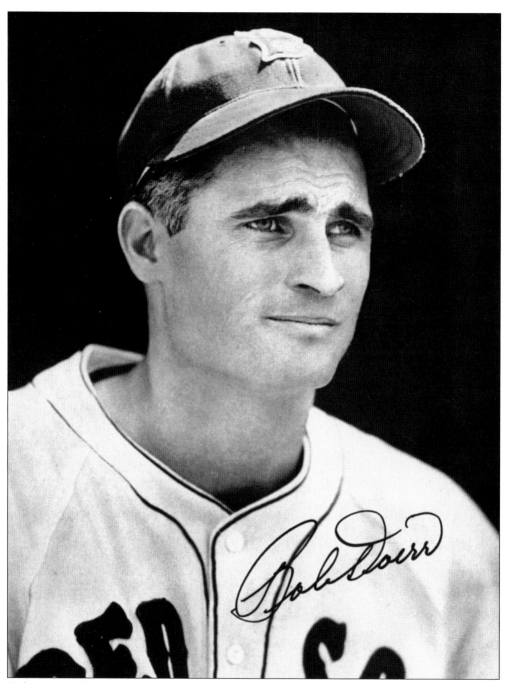

Help was on the way for the eventual turnaround in Red Sox fortunes. The first of the new arrivals who would become the foundation for future success was Bobby Doerr (1937–1951), the greatest second baseman in team history. His number (1) is one of only five Red Sox retired numbers. Doerr arrived in Boston in 1937 and hit a solid .289, with 5 home runs and 80 runs batted in during his first full season in Boston (1938). He followed up with his first .300 season (.318) the next year. Ranking in the top five in nine all-time categories, the Red Sox captain in the late 1940s was elected to the National Baseball Hall of Fame in 1986.

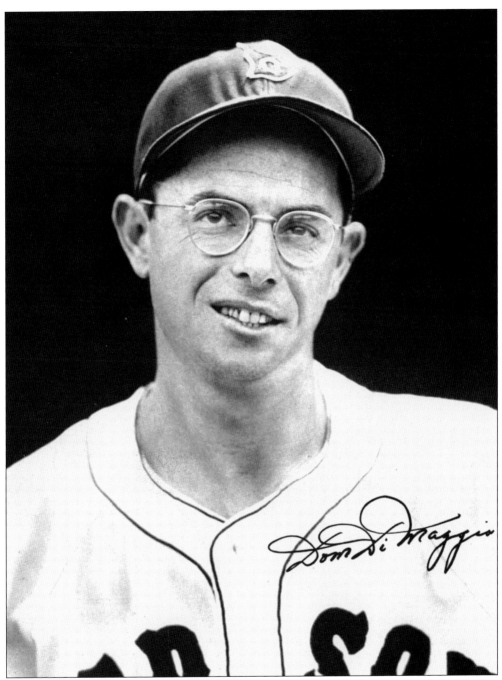

Center fielder Dom DiMaggio (1940–1953) was far more than the "younger brother of Joe" to Red Sox fans during his outstanding career. Not possessing the power of his brother, Dom was a highly adept table setter at the top of the potent Red Sox batting order. The "Little Professor" hit .301 in his first Red Sox season and averaged .298 for his career, which was spent entirely in Boston. In 11 seasons, he scored 1,046 runs and drew 750 walks in front of sluggers Ted Williams, Bobby Doerr, Vern Stephens, and Rudy York. DiMaggio and Doerr remain two of the most beloved of all Red Sox players.

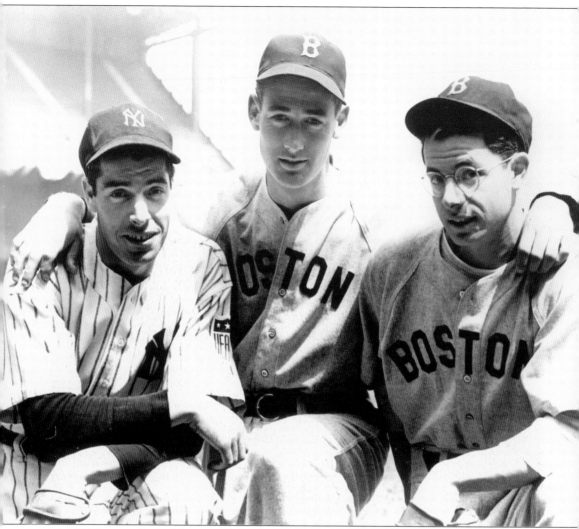

Ted Williams is flanked by two of the three DiMaggio brothers to play in the major leagues. New York Yankees center fielder Joe DiMaggio (left), one of the game's all-time greatest players, was Williams's greatest personal rival in the Yankee–Red Sox wars from (1939–1951). Red Sox center fielder Dom DiMaggio remained one of Williams's closest friends.

Six

THE KID

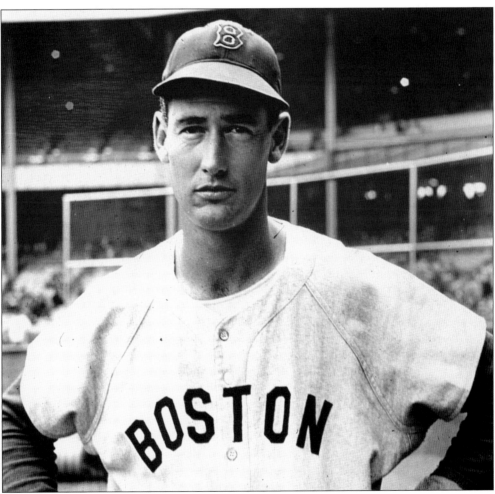

The "Kid" is shown as a kid in 1939. Ted Williams promptly led the American League in total bases (370) and runs batted in (145) while slugging 31 home runs and batting .327. His 107 walks represented the first of 11 times he broke the century mark in bases on balls, a tribute to his uncanny batting eye. The Red Sox finished second by 17 games to the Yankees.

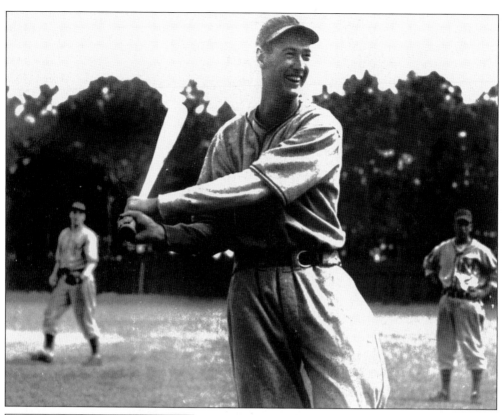

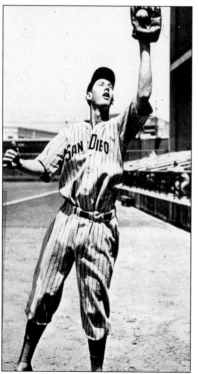

Ted Williams is shown in Minnesota (above) and in San Diego (left). As a 17-year-old local product fresh out of high school, he reported to the nearby San Diego club of the Pacific Coast League to begin his professional baseball career. His first year, in 42 games, he hit .271 with no home runs and 11 runs batted in. The next season, his first full year in professional baseball, he began to assert himself, hitting .291 with 23 home runs and 98 runs batted in. For the full season of 1938, Ted played for Minneapolis of the American Association. He was ready to ascend the Red Sox farm system ladder the following year.

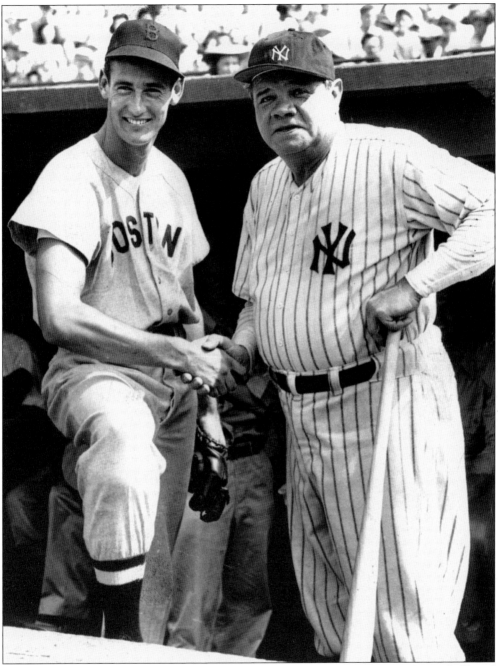

This is the only known photograph of two of the game's greatest: Ted Williams (left) and Babe Ruth.

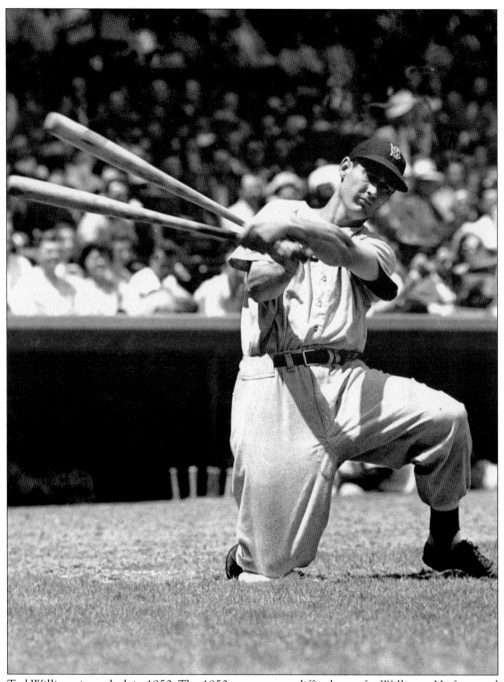

Ted Williams is on deck in 1950. The 1950 season was a difficult one for Williams. He fractured his left elbow crashing into the left-field wall at Chicago's Comiskey Park in the first inning of the 1950 All-Star game. After the All-Star break, he played just 19 more games, finishing with 28 home runs, 97 runs batted in, and a .317 average in an abbreviated 89-game season.

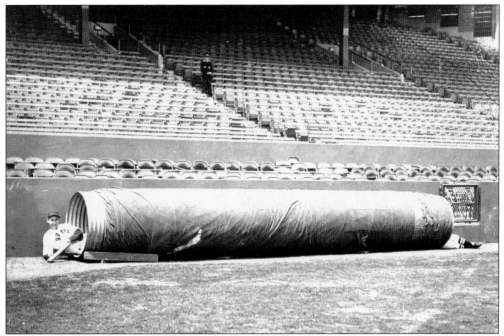

A young Ted Williams lightens up the proceedings with a little horseplay by "hiding" in a pipe used by the grounds crew to coil the tarpaulin. He appears appreciatively taller than six feet two inches.

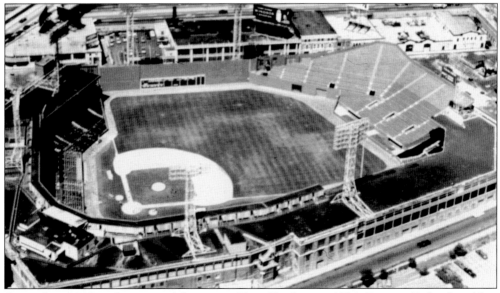

Opened in 1912 and renovated by owner Tom Yawkey in 1934, Fenway Park, the oldest ballpark in major-league baseball, has lost none of its charm in 90 years. It consistently ranks at the top among Boston's tourist attractions. It appears to be here to stay for the foreseeable future, allowing a unique baseball experience for children of all ages.

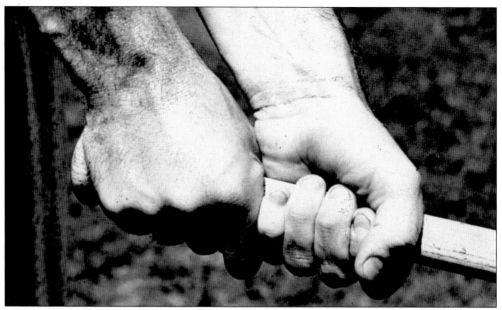

Ted Williams ascribed to the theory that "hands and hips" were the two essential elements of good hitting mechanics. The famous Williams grip of the bat is depicted here.

Cleveland player-manager Lou Boudreau devised the "Williams shift" for the purpose of better defending against Ted Williams. Boudreau, the Indians' outstanding fielding shortstop, brought the third baseman to the shortstop hole, placed himself behind second base, and moved the right side of his infield toward the first-base line. The shift presented some problems for Williams at first, but he was soon able to solidify his standing as "greatest hitter" by making the necessary adjustment and not allowing the shift or any opposing pitcher to get the best of him.

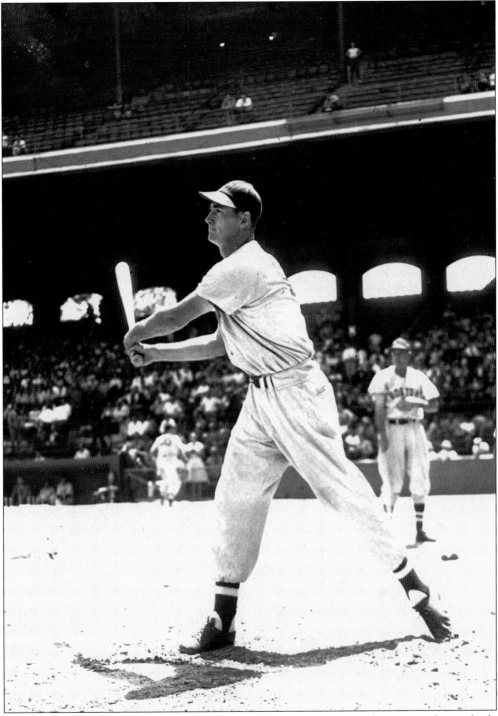

Ted Williams demonstrates his textbook positioning in the batter's box. Note the perfectly balanced body and concentration.

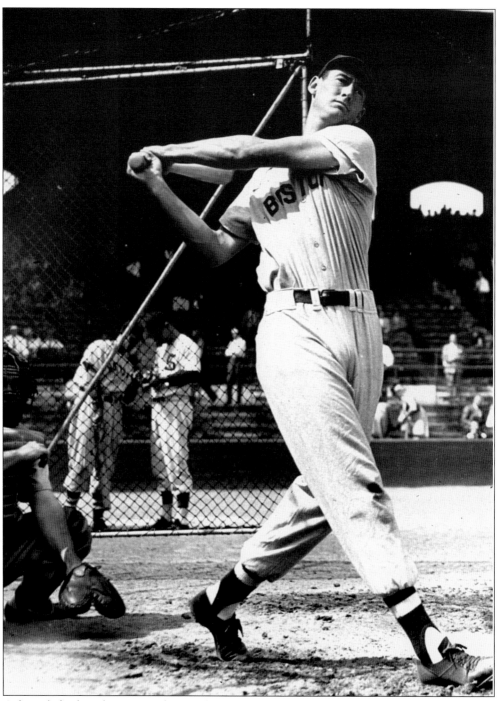

Acknowledged as the greatest hitter who ever lived, Ted Williams displays his body position after the swing. Note the fact that the eyes have still not left the ball.

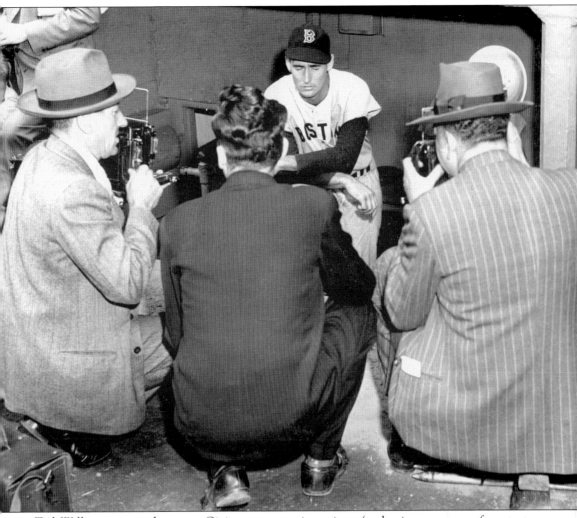

Ted Williams meets the press. Giving postgame interviews (or having any type of contact with the media) was not his favorite part of being a ballplayer. He often felt misrepresented by members of the press and their interpretations of his comments. He disparagingly referred to sportswriters as the "knights of the keyboard."

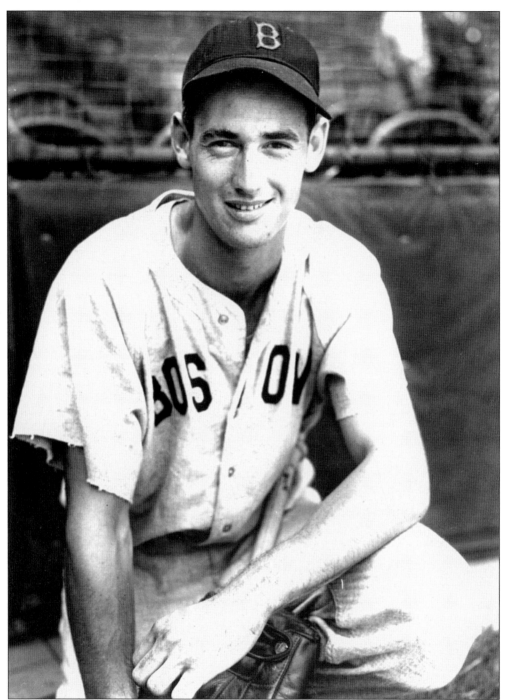

The Kid's career as a member of the Boston Red Sox spanned four decades (1939–1960), with time lost to military service in two wars (World War II and Korea). The constant was always his consistent hitting mechanics. In 1957, at 39 years old, Williams hit an amazing .388 to win his last American League batting crown.